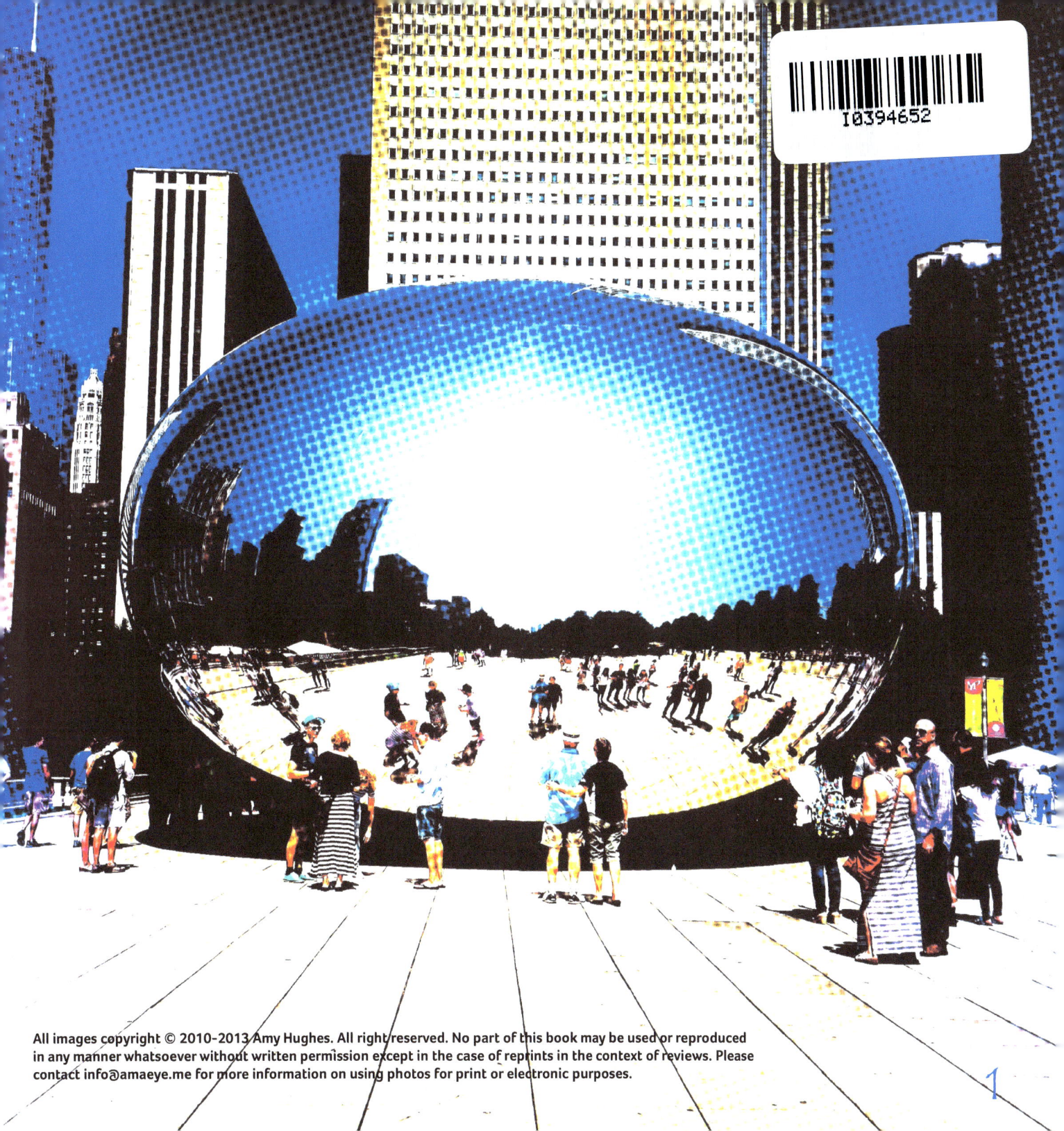

All images copyright © 2010-2013 Amy Hughes. All right reserved. No part of this book may be used or reproduced in any manner whatsoever without written permission except in the case of reprints in the context of reviews. Please contact info@amaeye.me for more information on using photos for print or electronic purposes.

moving still

CONTENTS

Who is Amaeye? — 4

EXPLORE — 6

Robyn Hitchcock Was My Sister — 22

Joe's Sneakers (& shoes & socks) — 40

sky Shots — 56

Light Impressions — 76

i leave u with — 78

Who is Amaeye?

My name is Amy Hughes. I was born in Boston, MA. A graduate of the Art Institute of Boston, I began my career as a paste-up artist at a small ad agency. Introduced to the world of Apple computers in the mid-eighties, I have been on the platform since then. But to understand the visual space I inhabit in my mind, I have to go back to my earliest memory of the camera.

I remember my dad's Polaroid Land 100 camera. As a youngster, this gadget fascinated me. He would leave it in a top drawer with the cover on, only to be removed for special occasions. The trick was to remove the cover very gently and let it hang down, adjust the bellows with two hands, look thru the small square viewfinder and then you could depress the red shutter button; it was all in the timing.

As I got older I graduated to other cameras and the world opened up. I was more in control and could look at the world in a different perspective. I borrowed the camera that was handy in the house - a Kodak 126 - and started shooting. Staging events with my sister, looking at an old hubcap, posing my friends - satisfied my need to create. I felt no restrictions, no one told me if my photos were good or bad, I just liked taking pictures.

During my high school years in Billerica, MA I managed to spend a good deal of time in the darkroom. The process of developing film and printing was sometimes tedious, sometimes fascinating. Senior year was a near hibernation spent in closed rooms, breaking open canisters of Kodak or sliding 4x5 negatives into metal sleeves, overcome with noxious vapors and a near electrocution from a timer with wet hands.

Art school was not far behind. Although my major was design, time spent in the building's basement photography studio was part of my studies. I was able to purchase my first serious camera: the Pentax K-1000 in 1983. This was the first time I developed and printed color, had serious critiques of my work and collaborated with other students; it was a cool unstructured time.

My graduation sent me off to the world of design and paste-up work, but I continued to enjoy photography. I would spit out Polaroids and manipulate the development. I hooked up with close friends and would shoot black & white just for kicks. I eventually decided to give up the strict working world and delve into rock 'n roll: nothing to lose!

I gained a huge appreciation of music, Alternative was my specialty and in due time of the early to mid 90s, I interviewed a caldron of musicians, most from Britain

getting their start in America and more specifically Boston. I often would photograph the gigs as well. I usually took two cameras, my Nikon SLR for the big important stuff and a Nikon point & shoot for off the cuff moments.

Word got round locally in Boston about my photography and I ended up doing some photo promotion work for the bands. I had been hanging with several groups and musicians around the time I was working at WCGY in Lawrence, MA. I would prep the interviews, talk a bit and later post the local playlist on that new-fangled place in space called America Online.

But around the late 90s, digital photography was getting a foothold in its popularity. I had moved to Chicago after meeting my now husband on AOL and the opportunity to photograph was starting to be a chore. Lugging a heavy camera was no joy and I eventually sold all my equipment. We purchased a Sony digital point & shoot, but I could never really get the hang of it. The interface was confusing and I didn't like the idea of holding it in front of me.

No camera really held my attention for quite a long time. As I busied myself with family, the opportunity to photograph again never came seriously. We'd capture moments for the future and store them on a computer. The days of taking photos and be excited by the experience were over, until 2007 and the iPhone.

I was remotely aware of this device given my lifelong attachment to Apple products. But the thought of owning one seemed distant considering the price tag and practicality. We already had cellphones, there was no need to invest in another gadget.

However in 2010 our phones were proving unreliable and clunky. We seriously thought do we need this toy? Inevitably we took the plunge and got the iPhone 3G. At first, I barely used it. I thought it had a pretty crappy camera with only 2 megapixels. Then I found an app called More Lomo: my world changed!

Since then I've graduated up to the term iPhoneographer (with thanks to Glyn Evans, who coined the moniker). I discovered a literal world-wide, like-minded people who were shooting exclusively with the iPhone. Did it matter we have never met in the real world? Not in the least. The shared passion and curiosity that surrounds this medium is unifying in and of itself.

I connected with hundreds: some serious photographers who abandoned traditional equipment, some who are designers, some who use their iPhone to visualize what they can't convey verbally and some who would be considered ordinary citizens of the Earth, yet their commitment in forwarding iPhone photography has turned them into pioneers.

I have thoroughly immersed myself, quite deeply I might add, into this realm. It's not hard to see why so many, including myself, cannot look back. I look forward constantly to help promote and discover new ways of capturing my world with the iPhone. It's how I live!

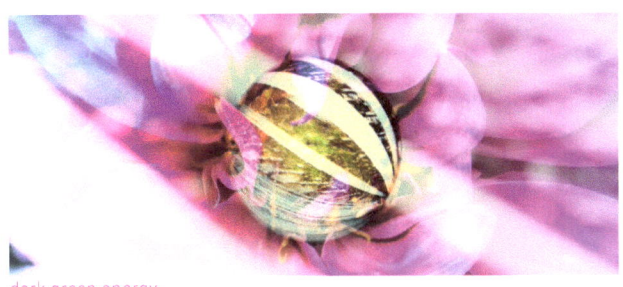

dark green energy

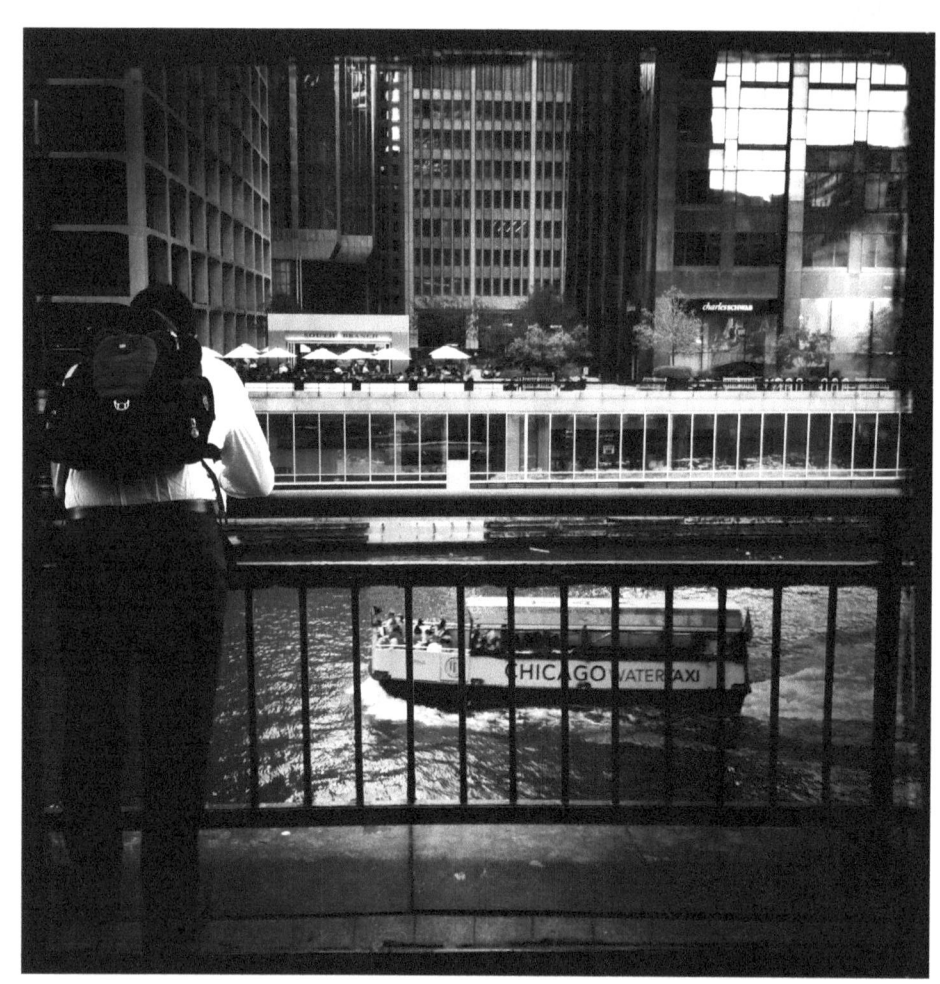

JUN 82

Photo Listing: (6) heading home, along the river (7) morning rays (8) right down the line; scarred; vivian's life lesson (9) rarefaction (10-11) unrememberance (12) rosemoor hotel (13) les brothers (14-15) the helicopter, the ledge and the sky (15) circumhorizontal arc (16) a brilliant burst from congress; the x factor (18-19) south wacker (20-21) 8 bubbles; 3 flowers at the park (21) red bike

EXPLORE

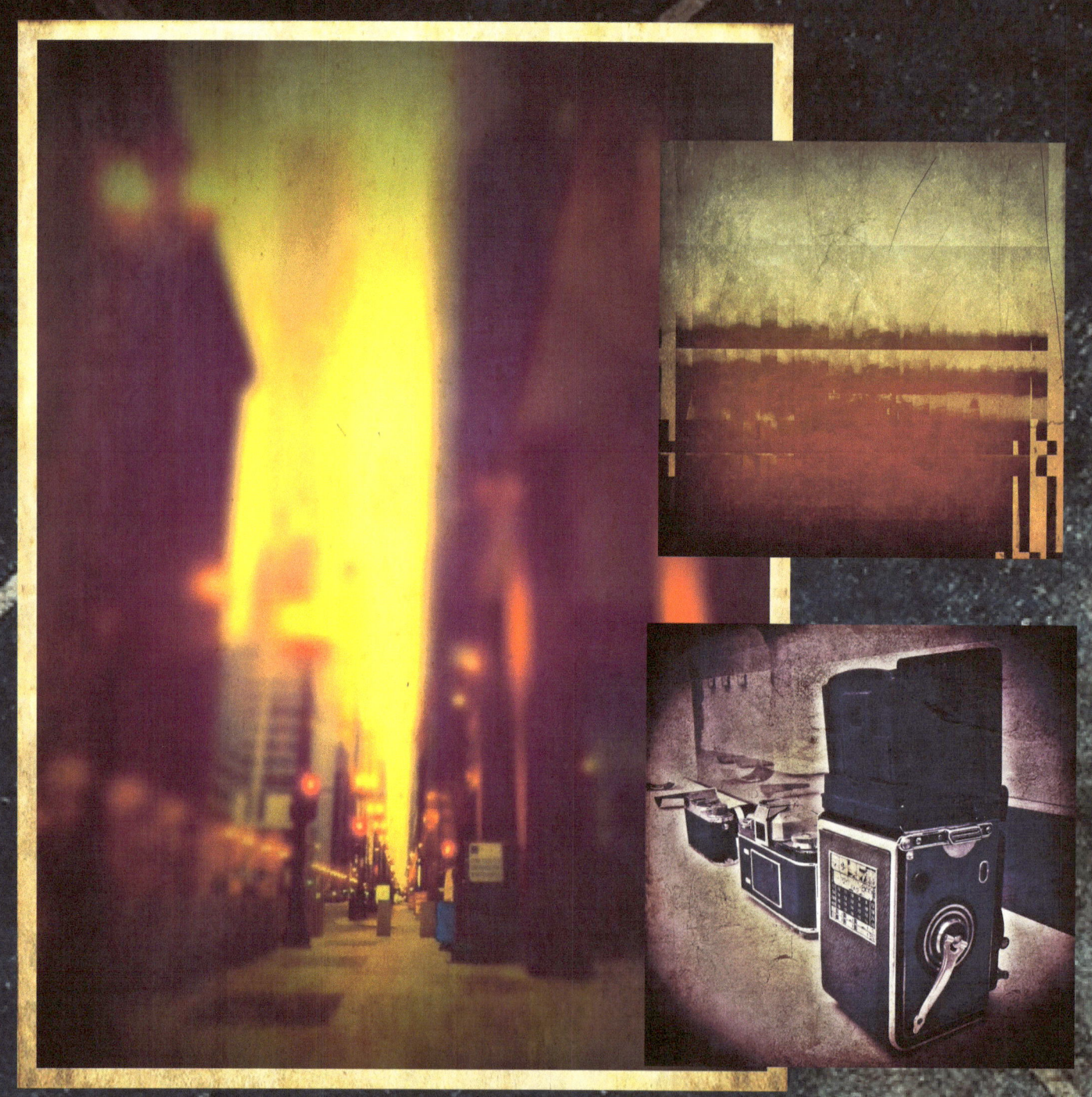

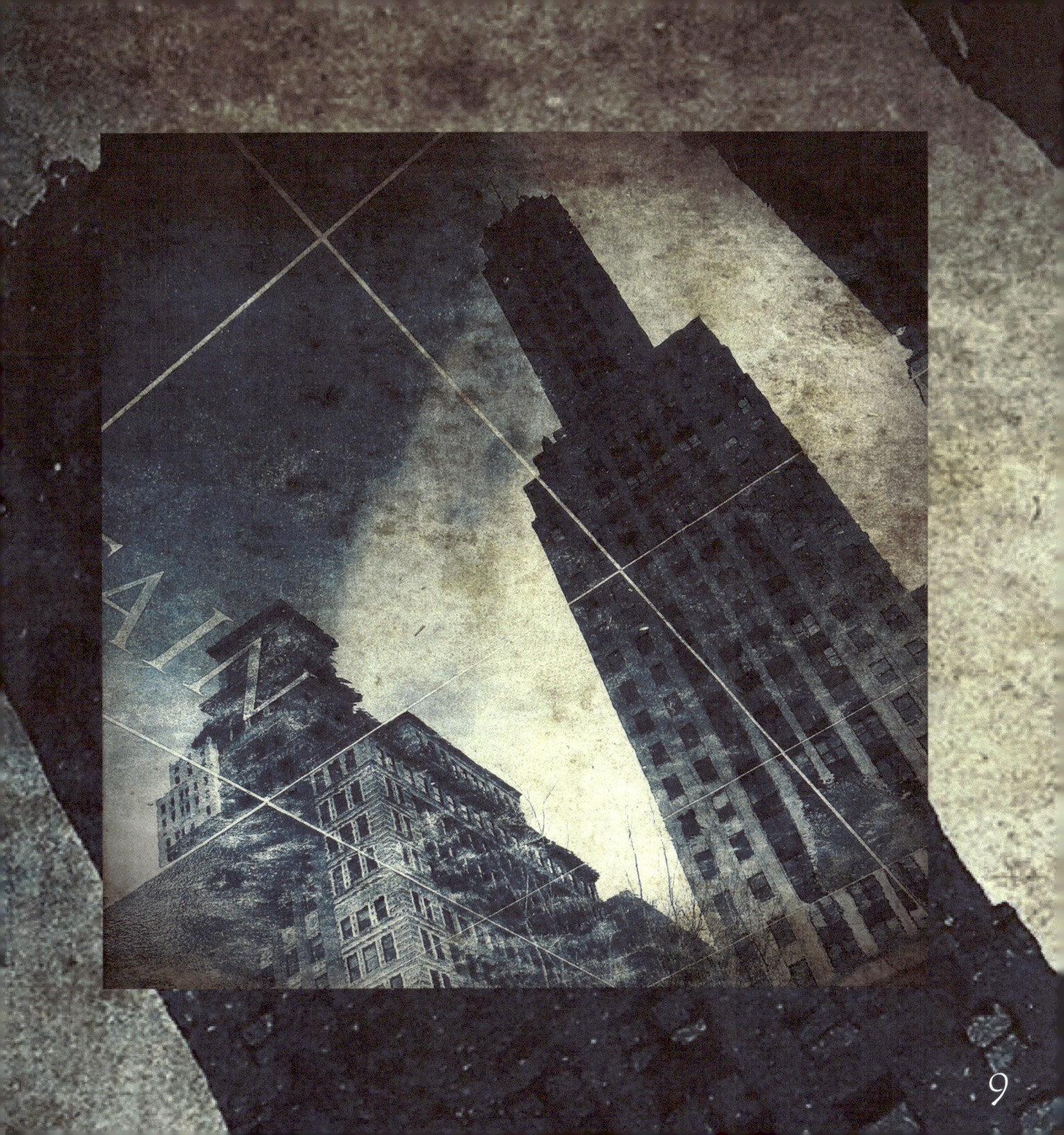

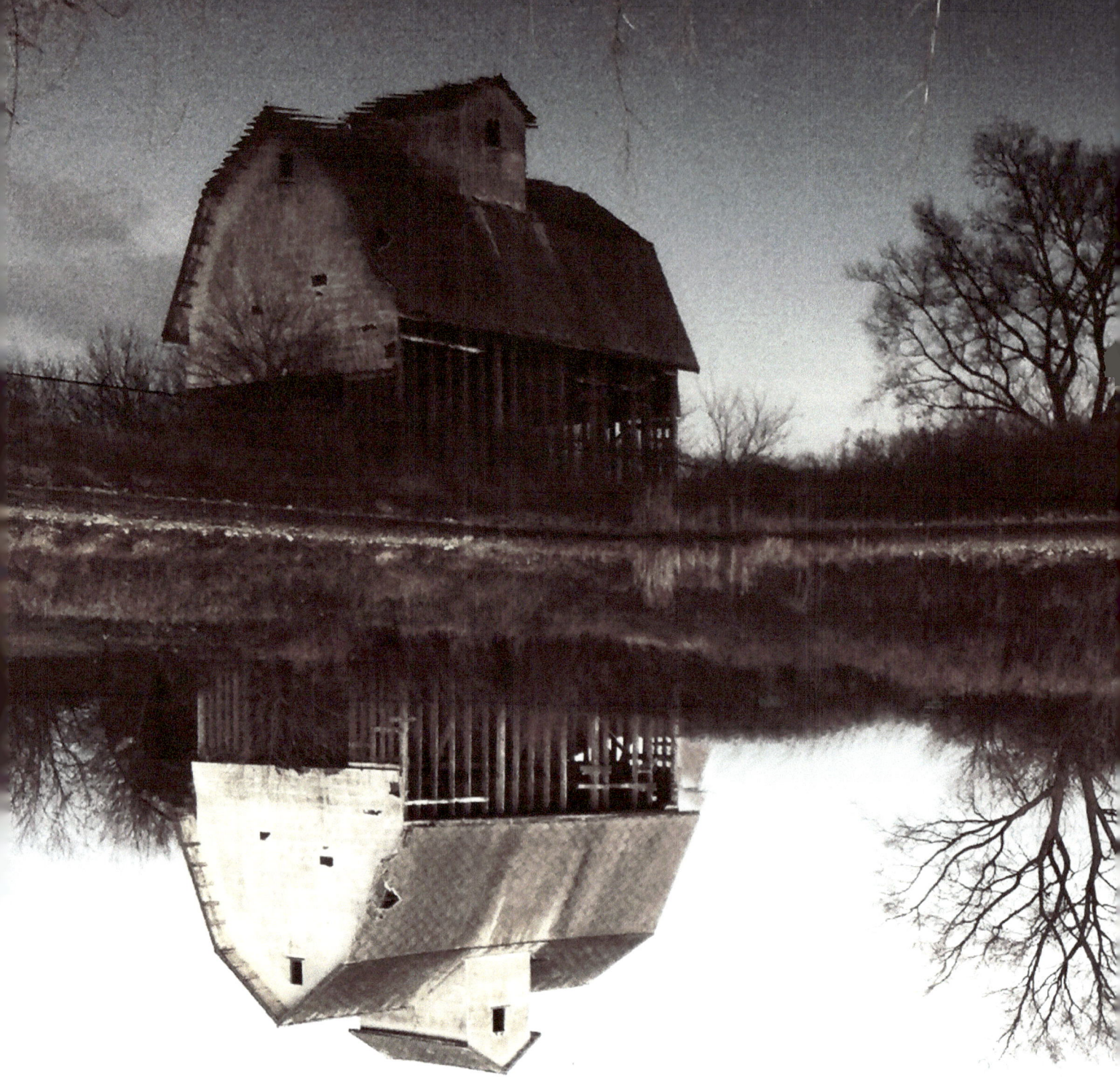

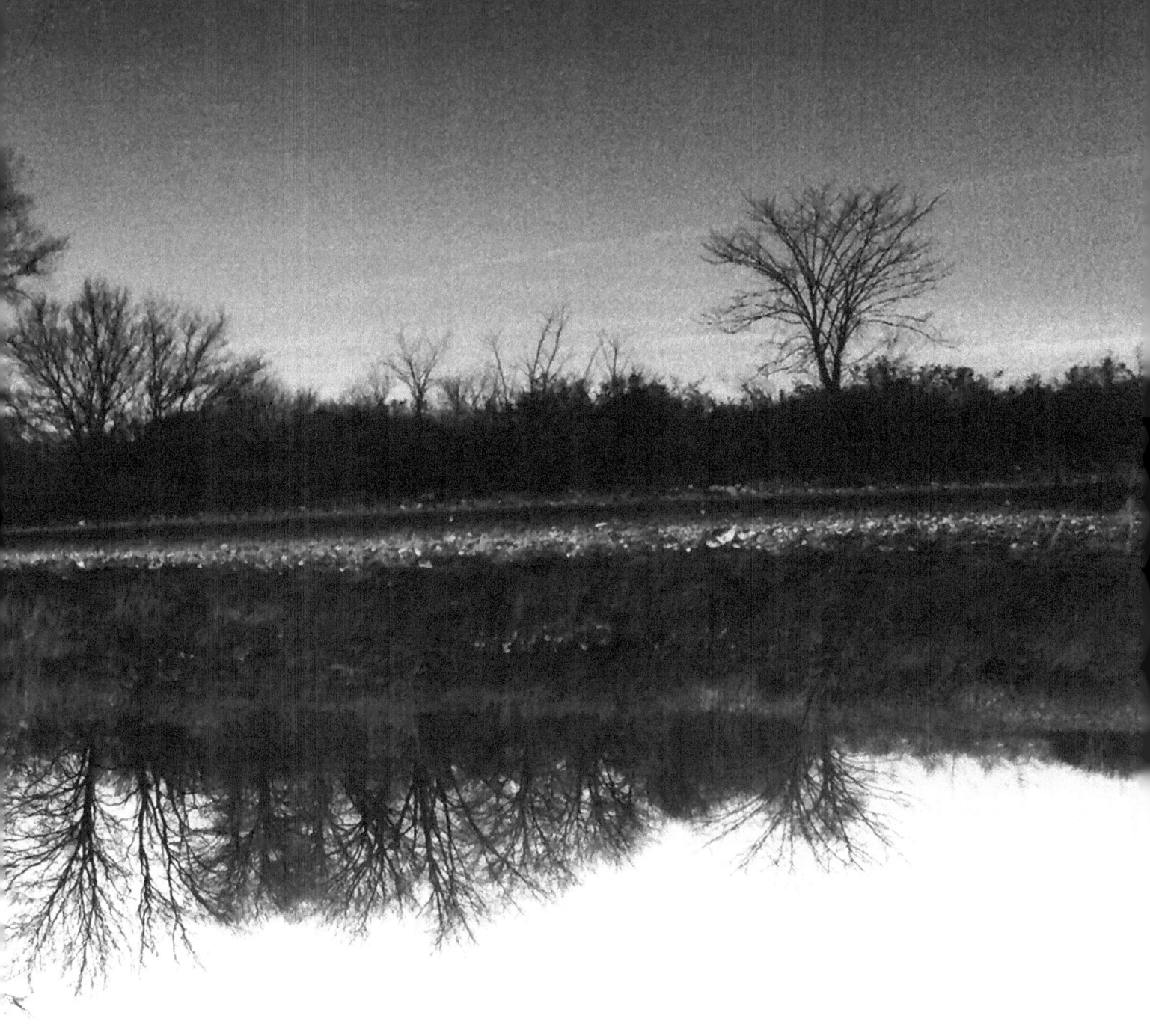

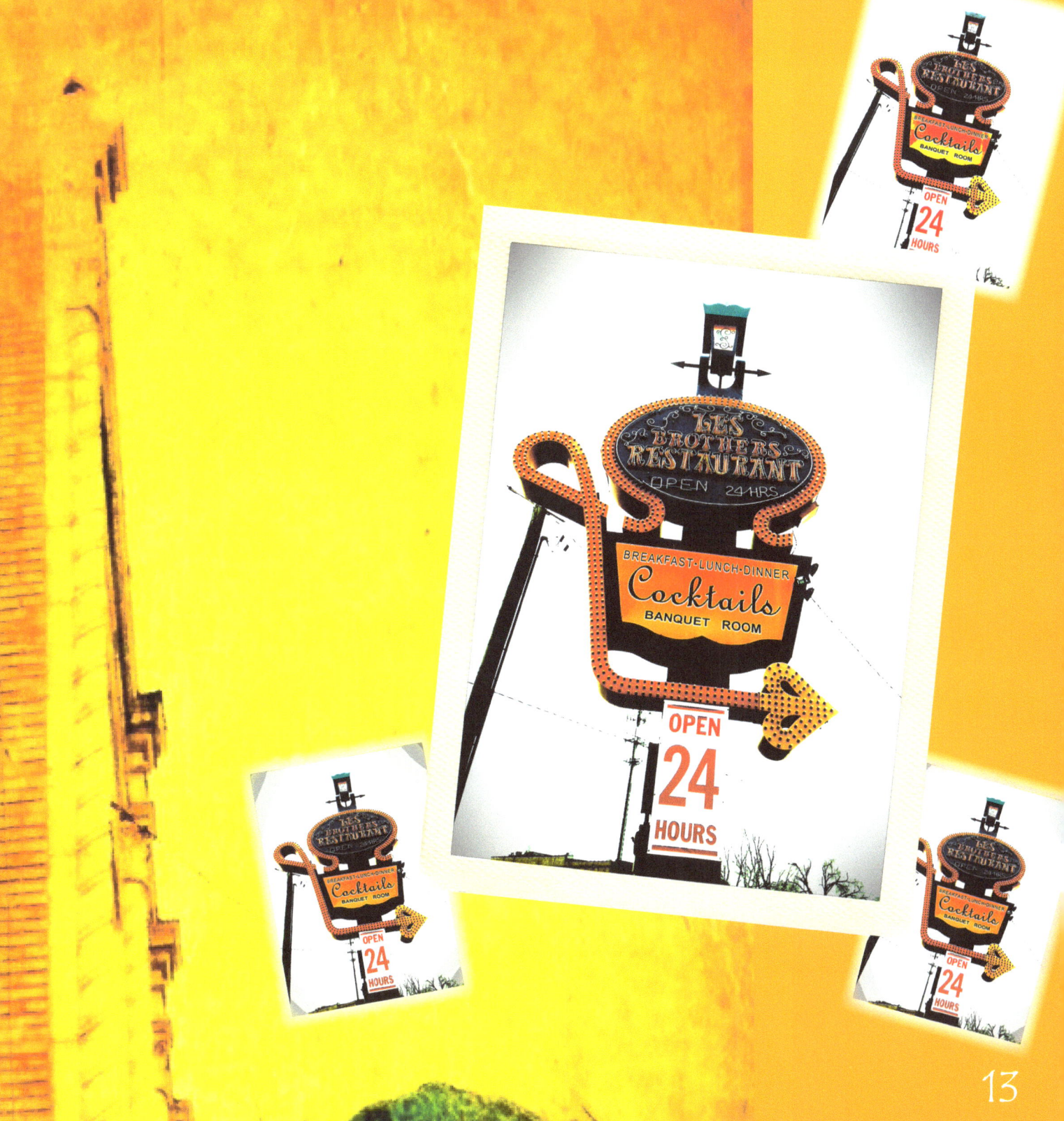

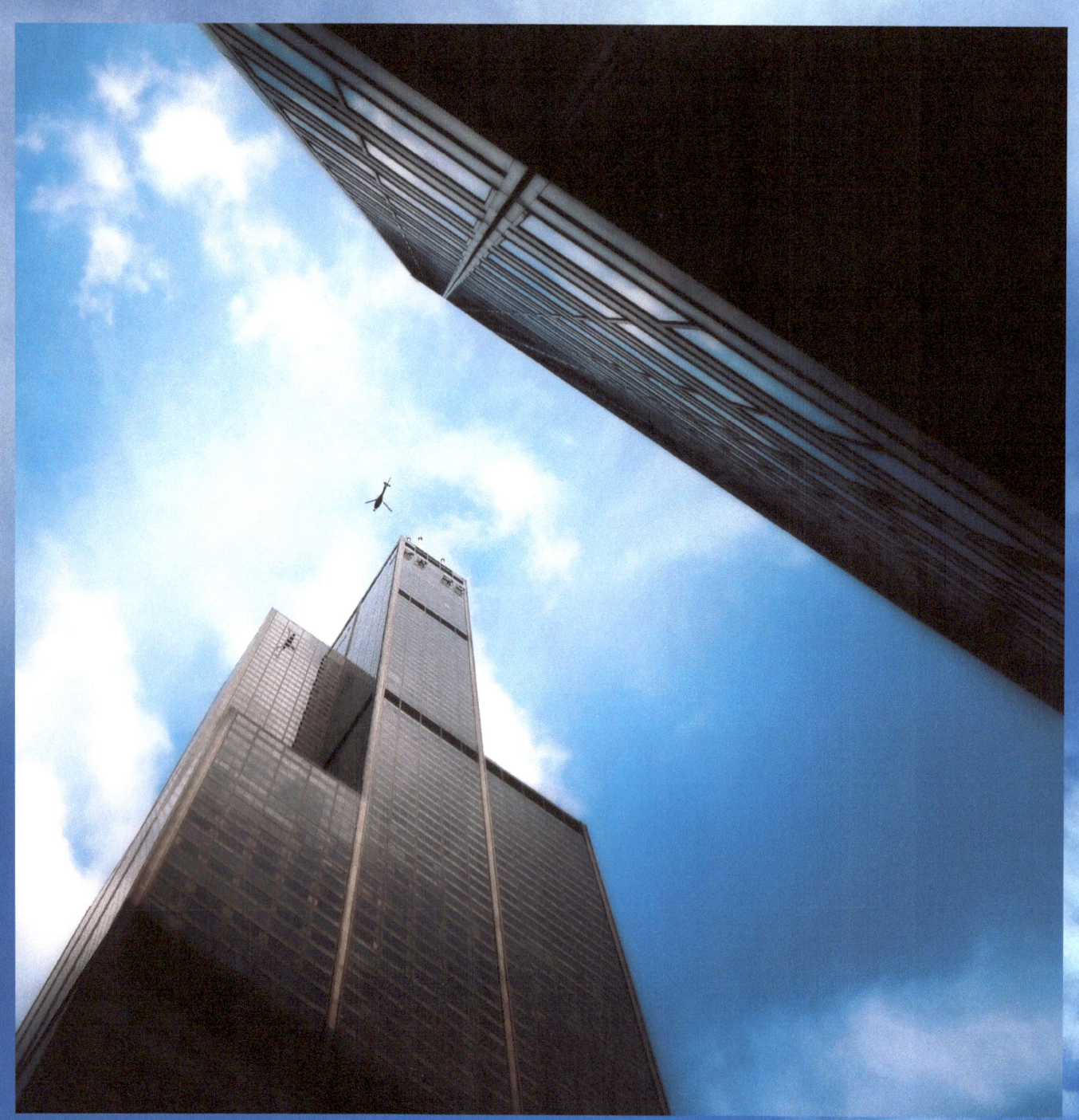

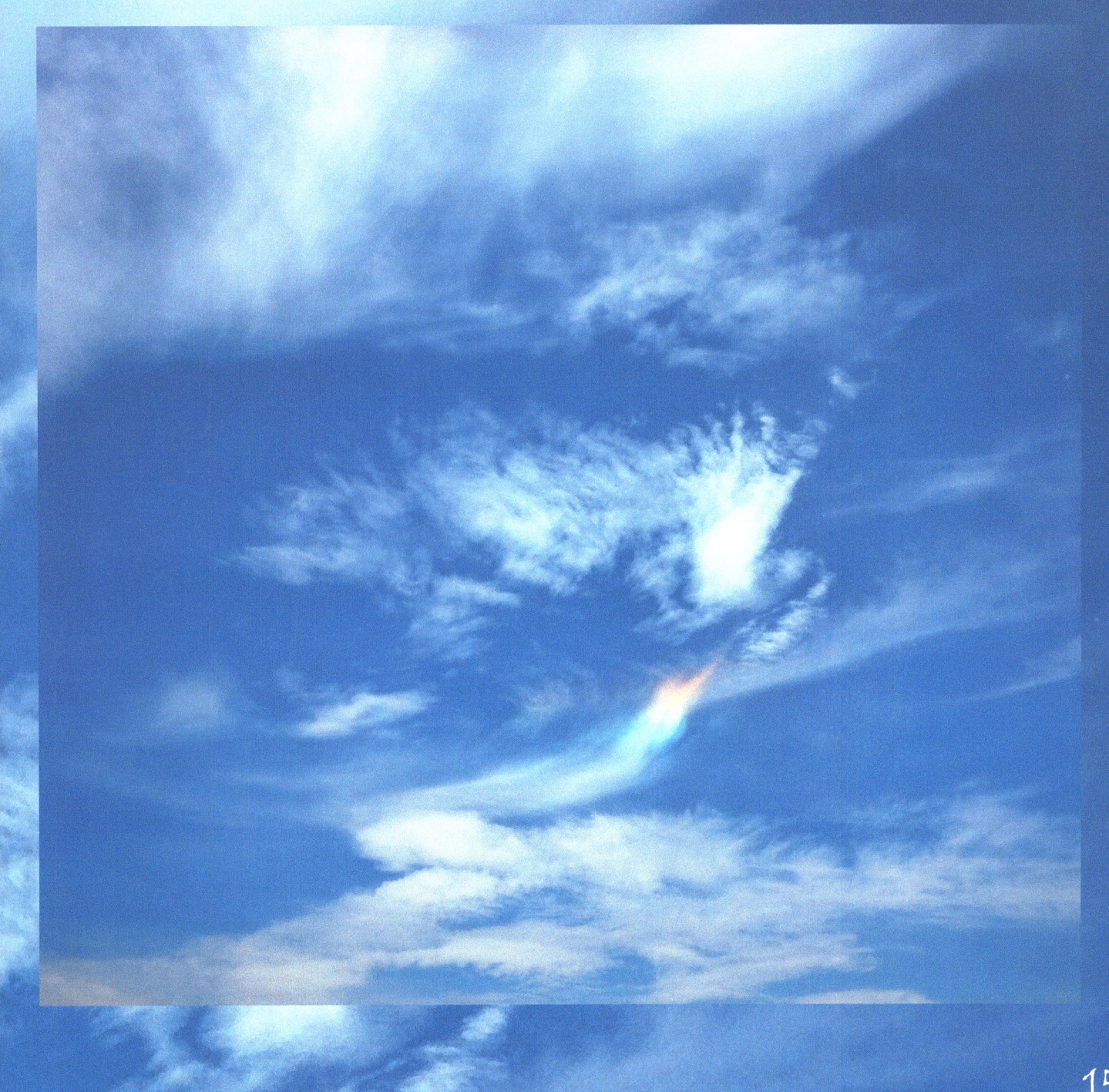

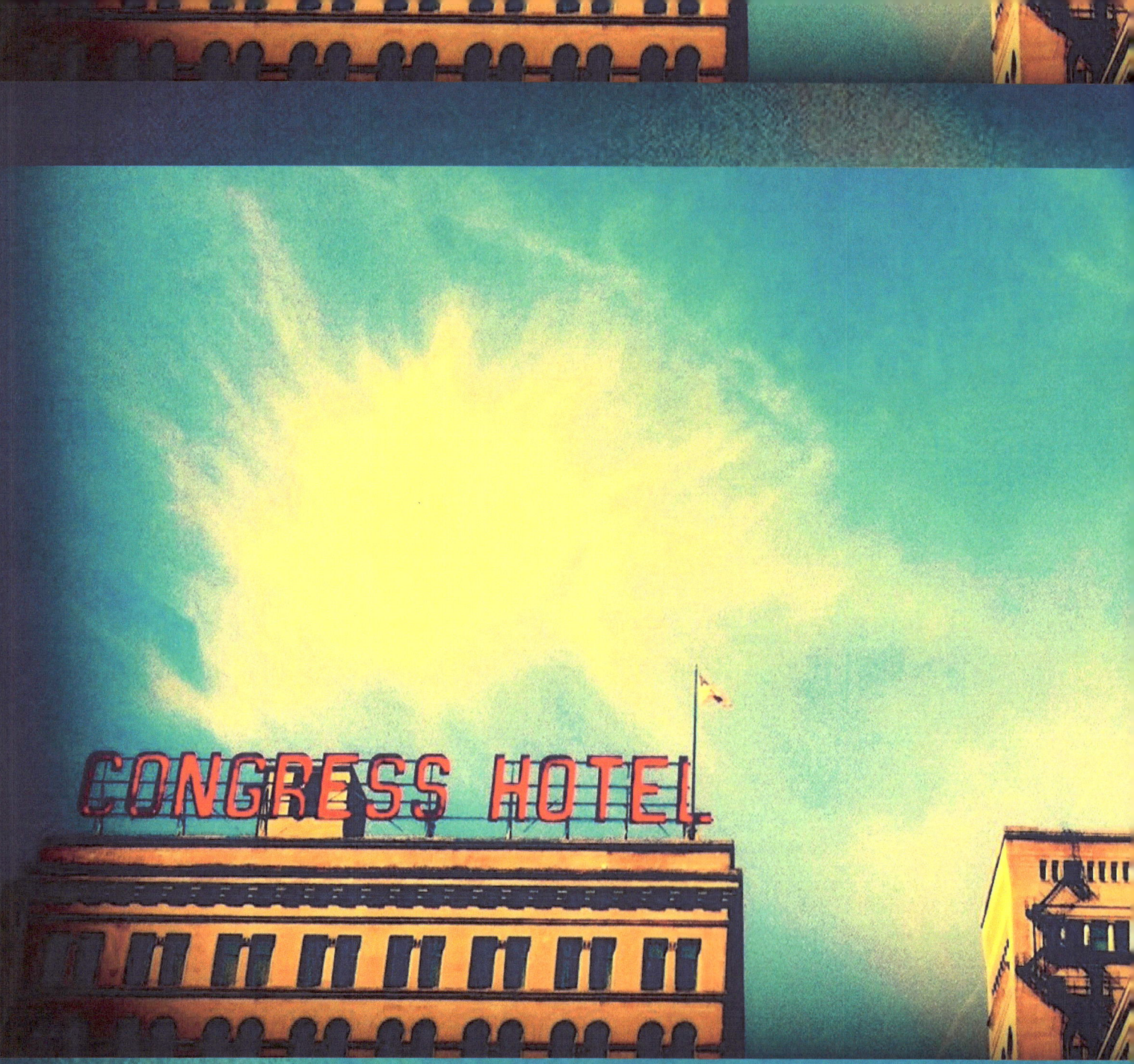

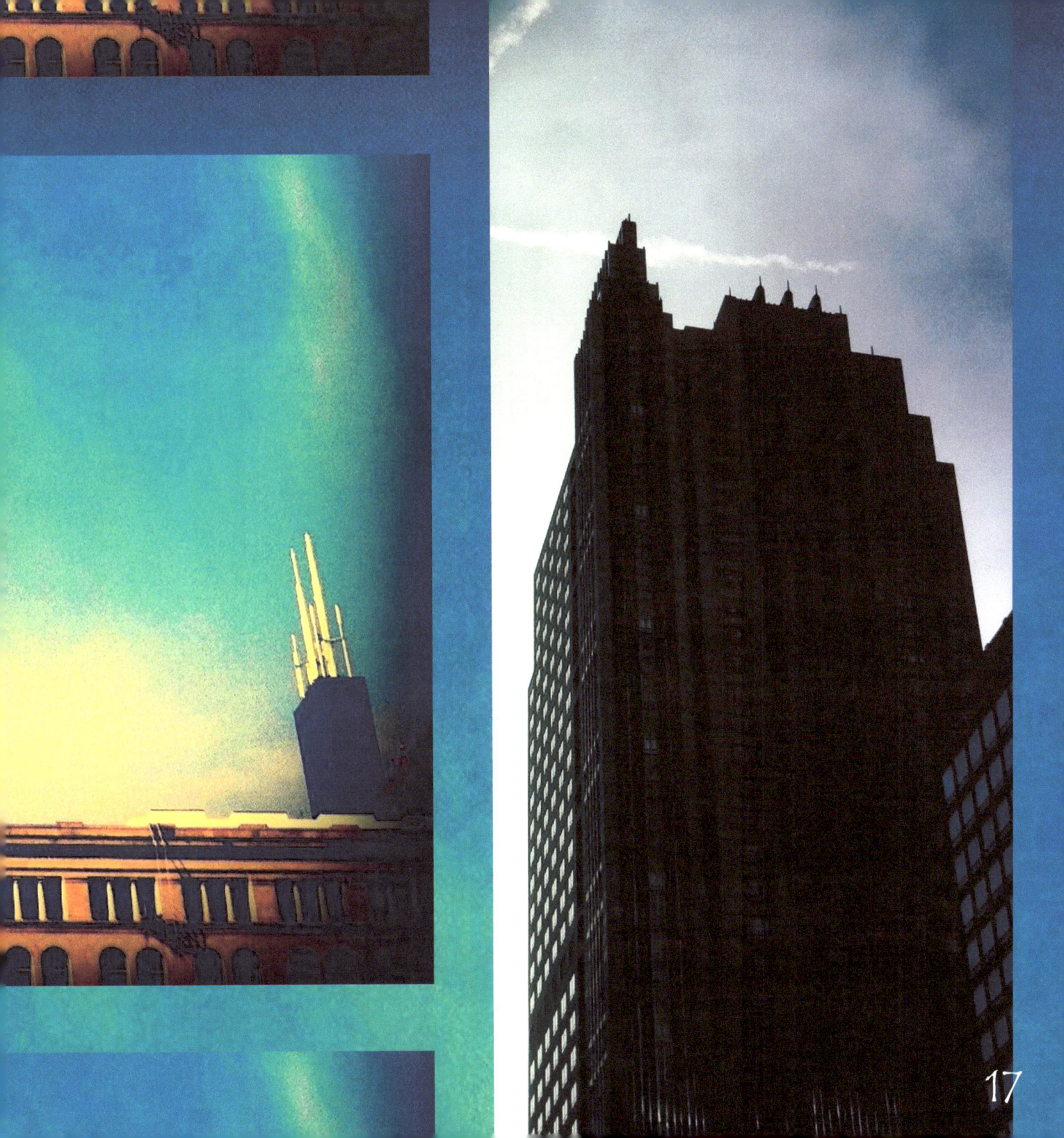

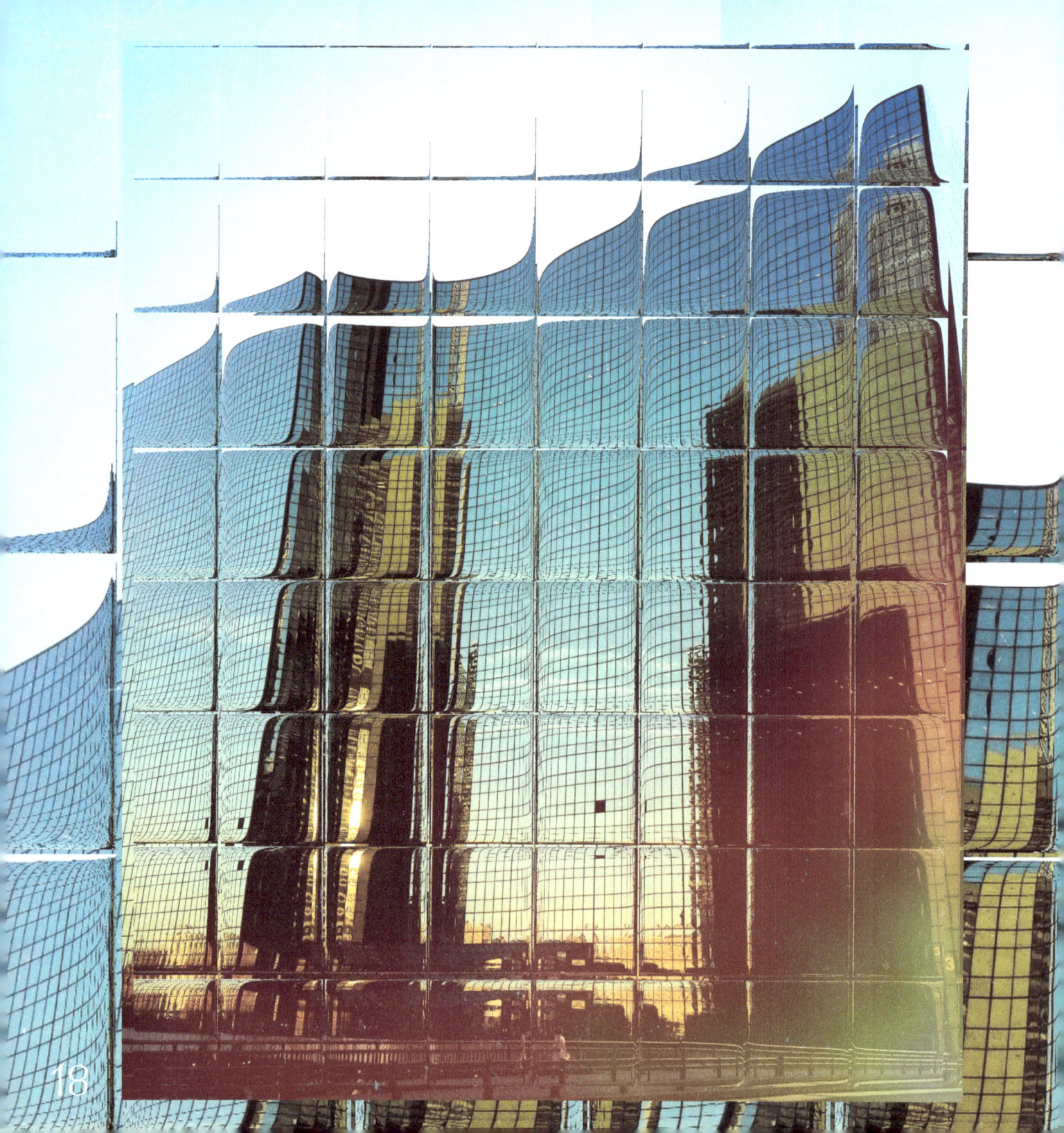

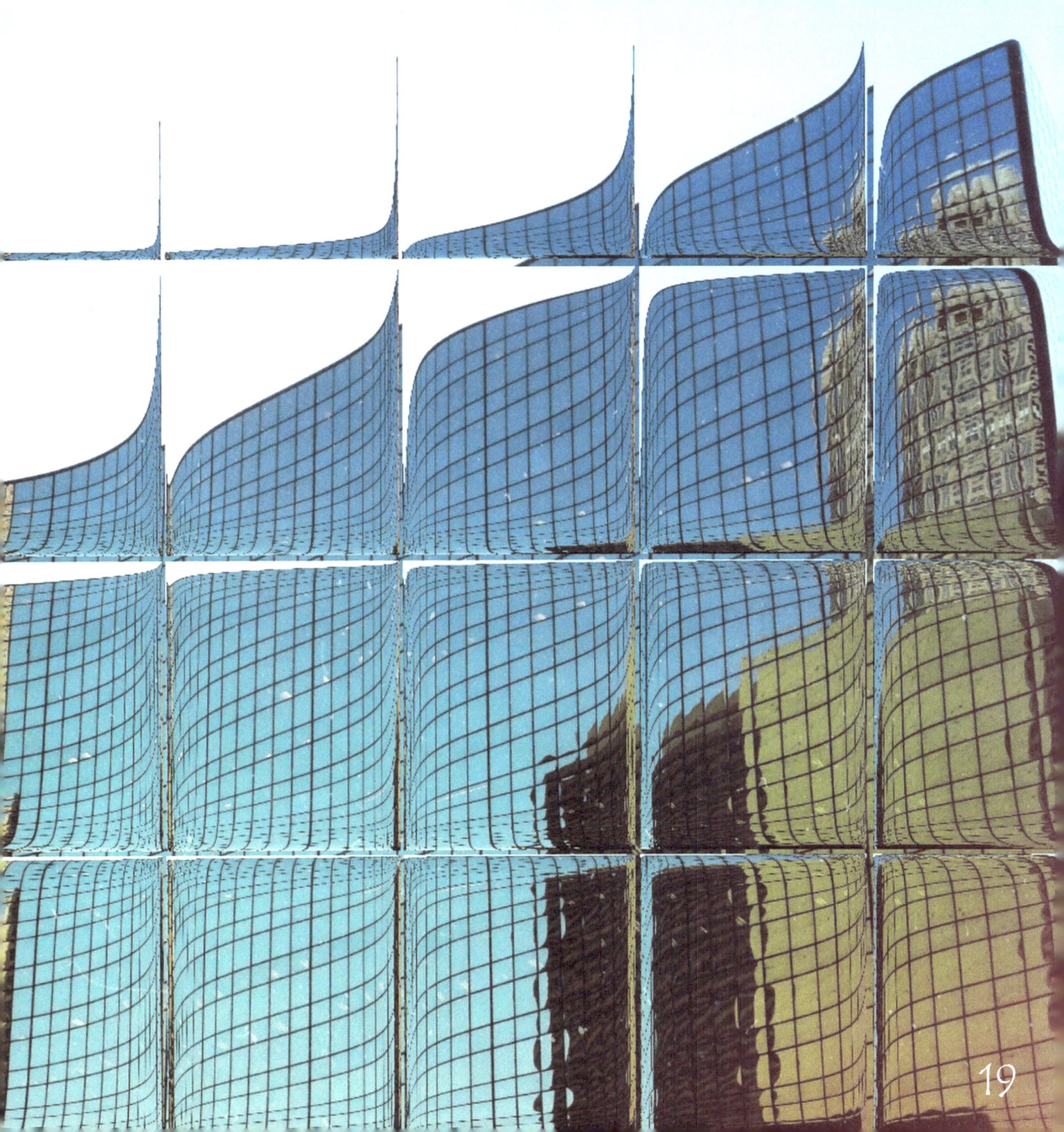

19

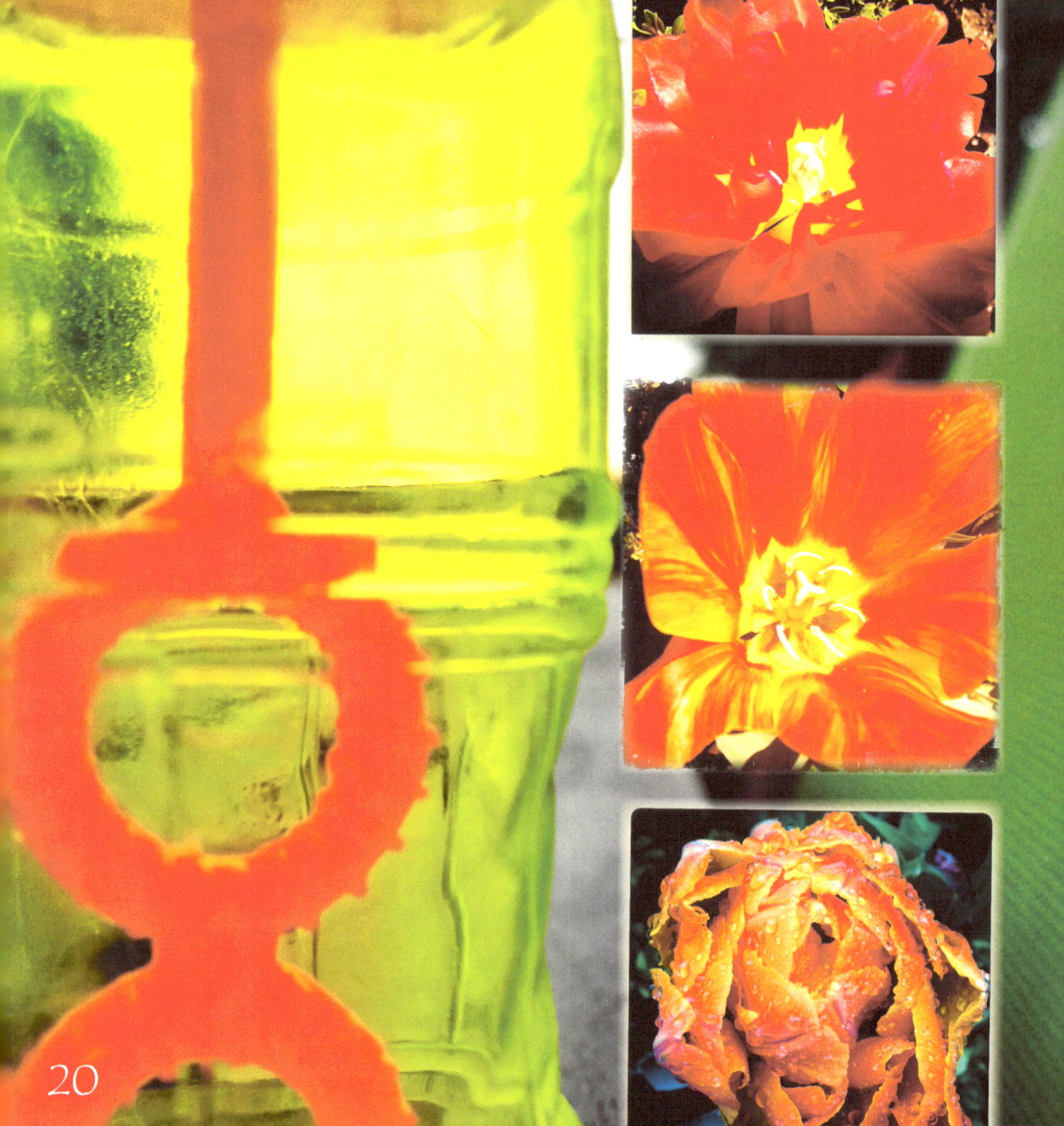

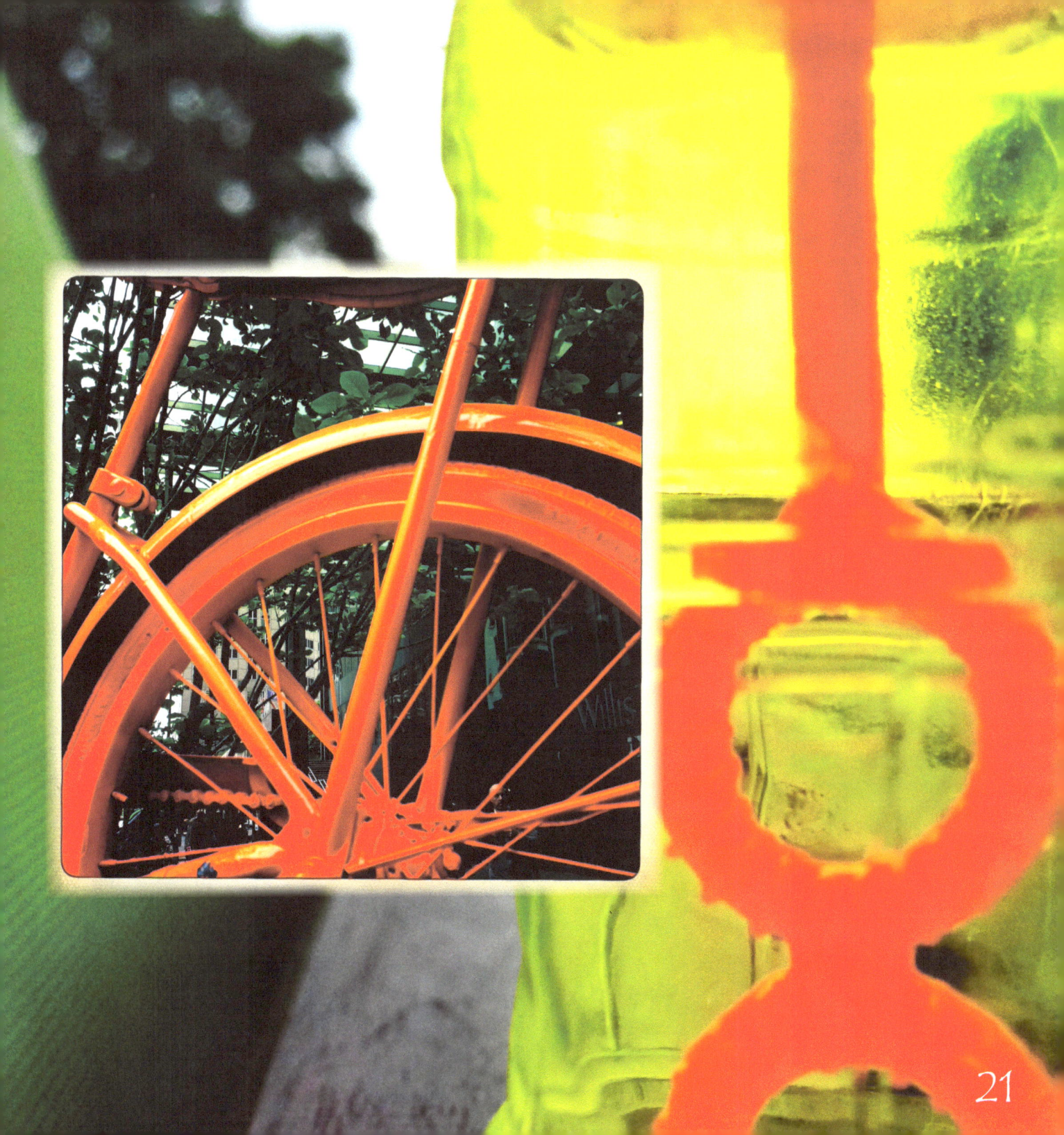

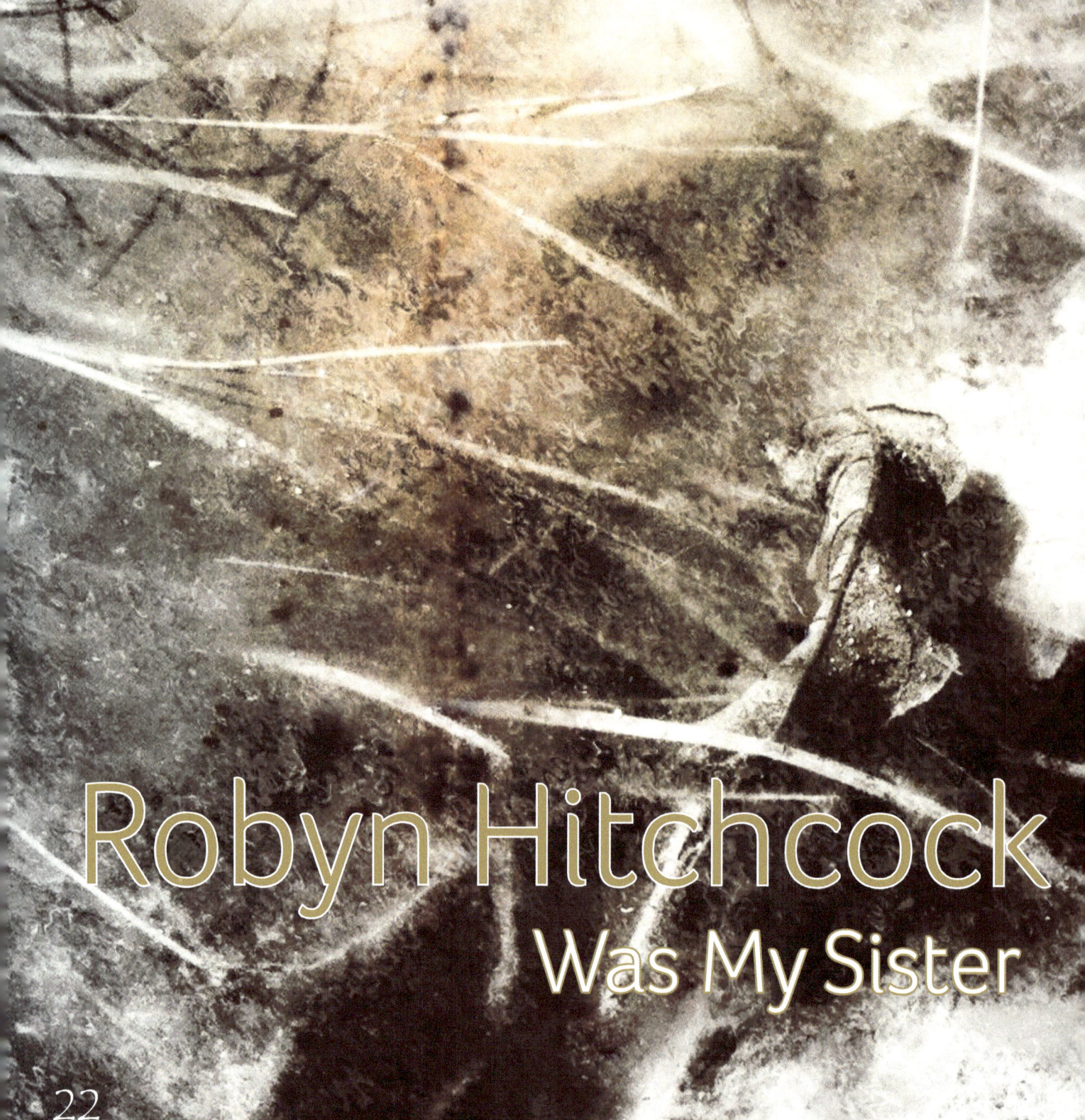

Photo Listing: (22-23) you're the reflection and i am the self (24-25) raymond chandler evening (26) things behind the sun (27) let's go thundering (28) i often dream of trains (29) sweet ghost of light (30) everything you say is like iron, it smashes me up but it's brittle inside (31) hieroglyphics on a yellow cone (32-33) the shapes between us turn into animals (34-35) you turn me on like light, a silver liquid light, yellow bricks bring drama (36) sometimes i wish i was a pretty girl (37) star of hairs (38) nietzsche's way; madonna of the wasps; lady waters and the hooded one (39) full moon in my soul; i saw nick drake

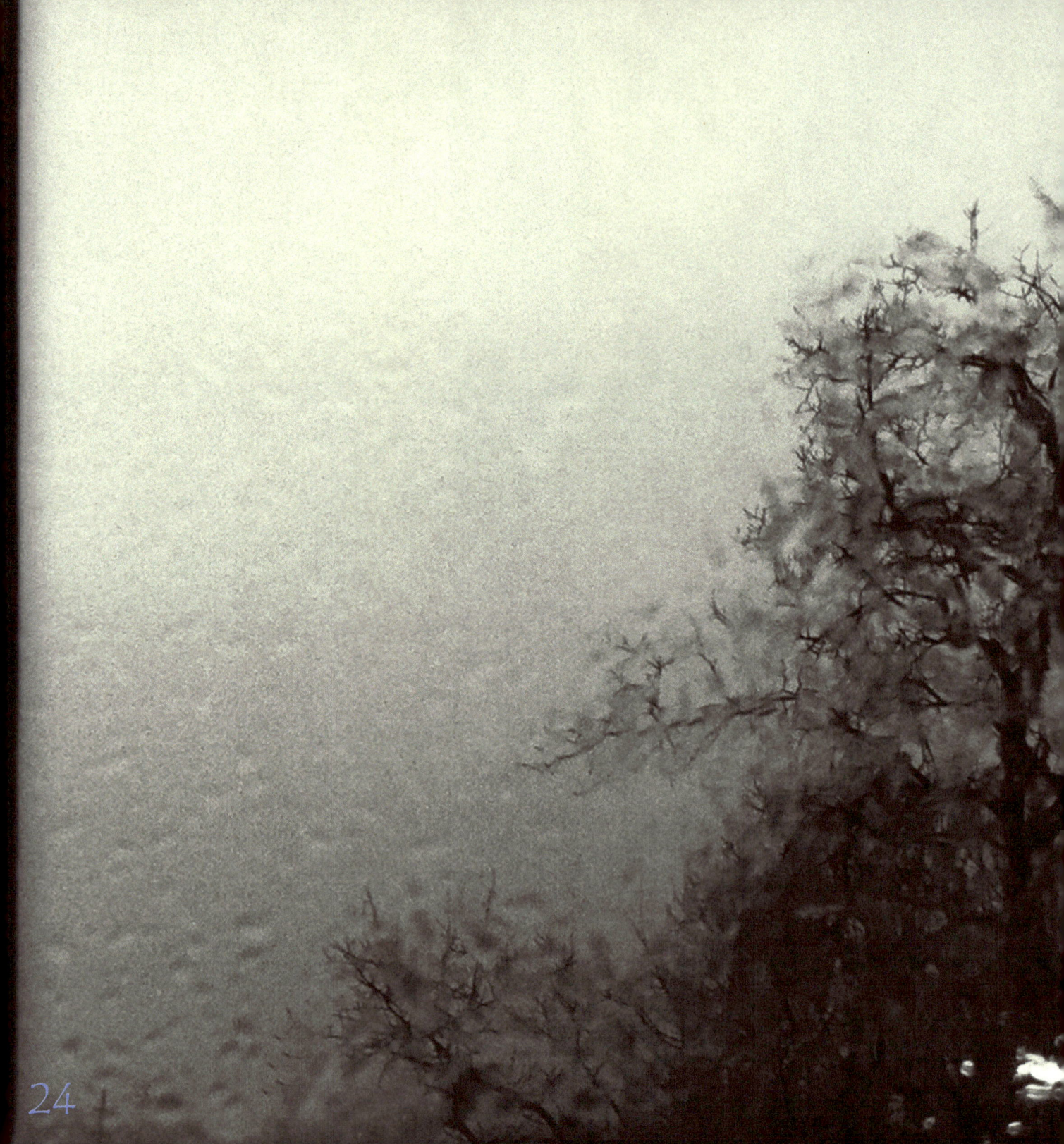

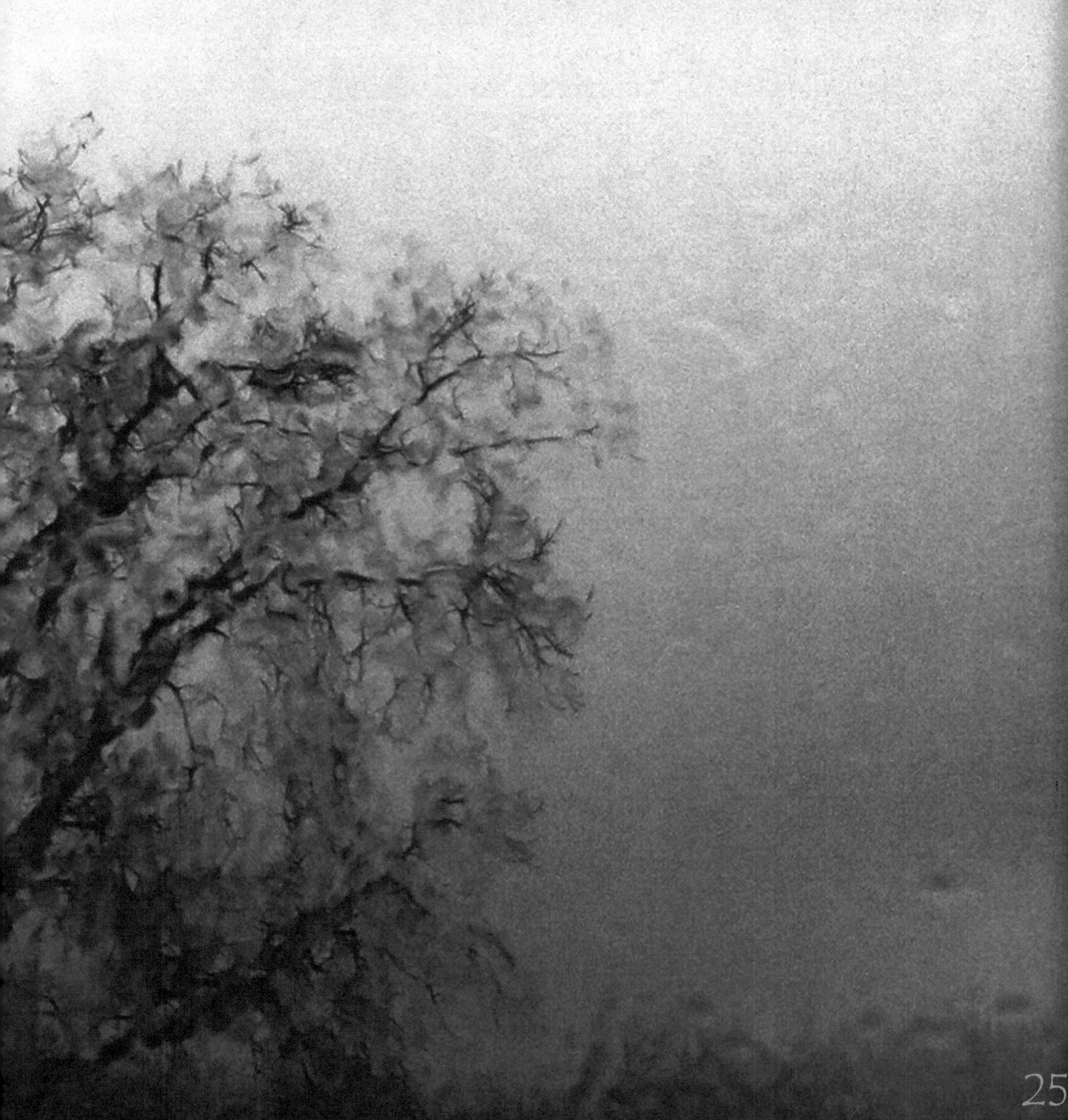

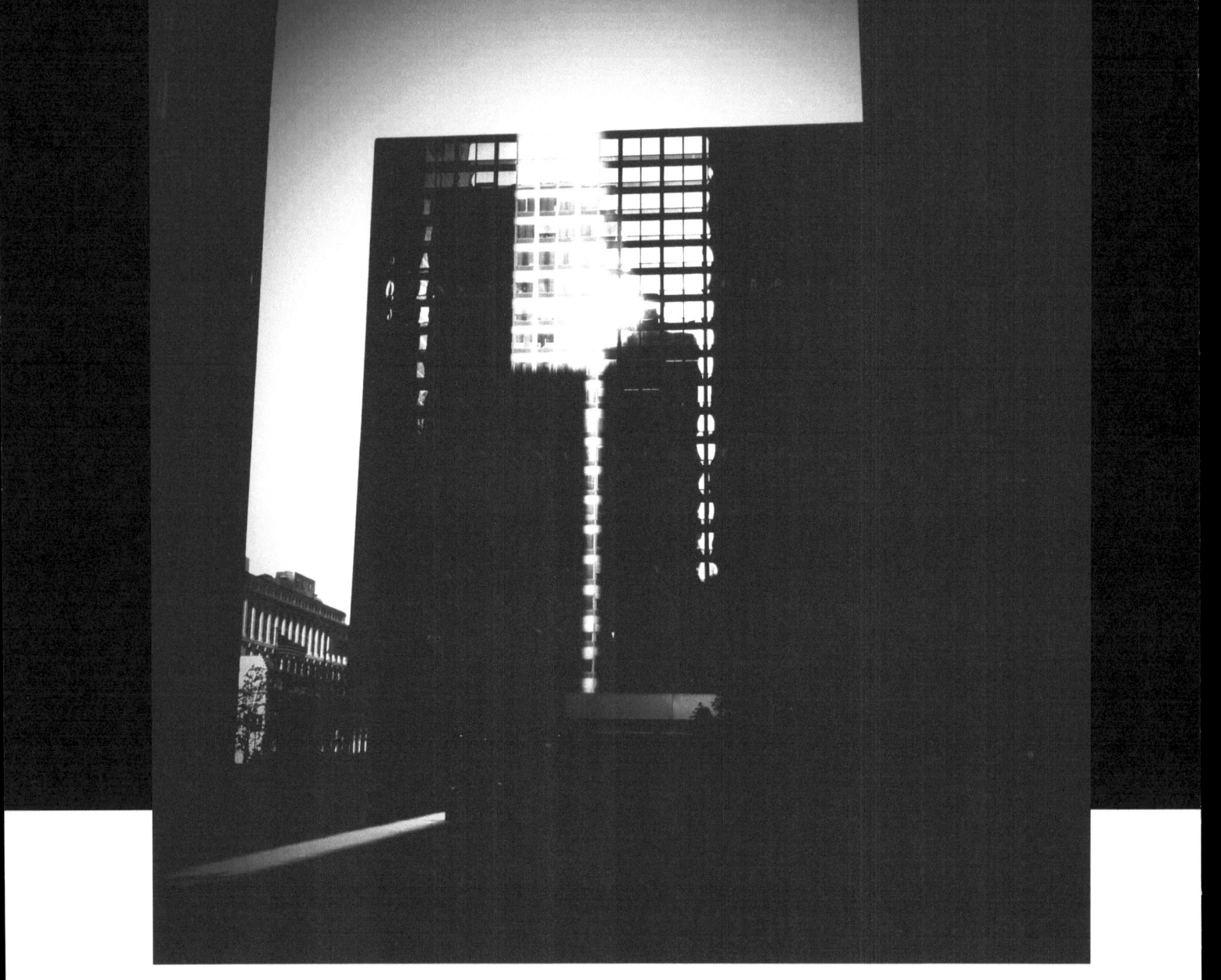

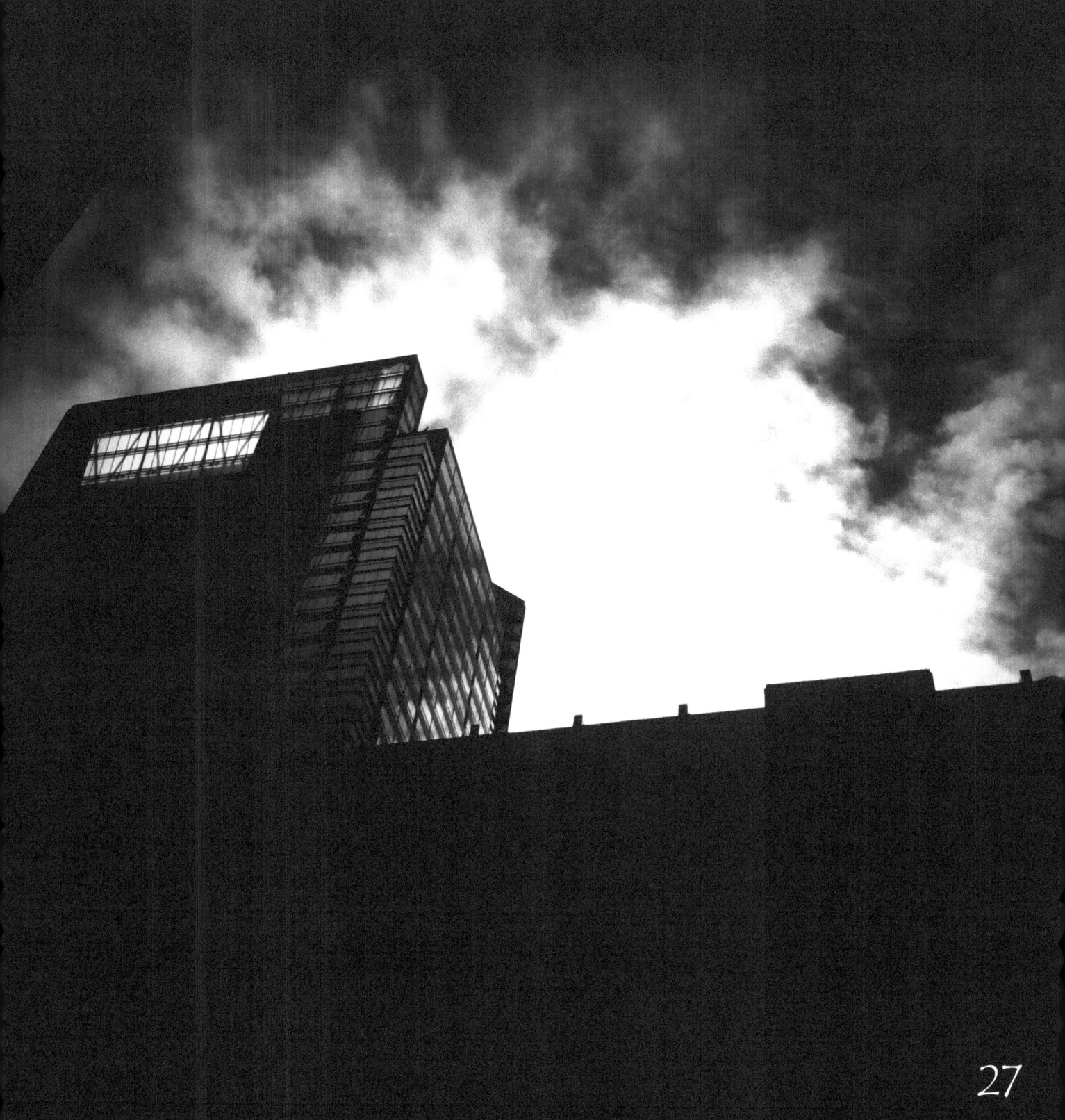

27

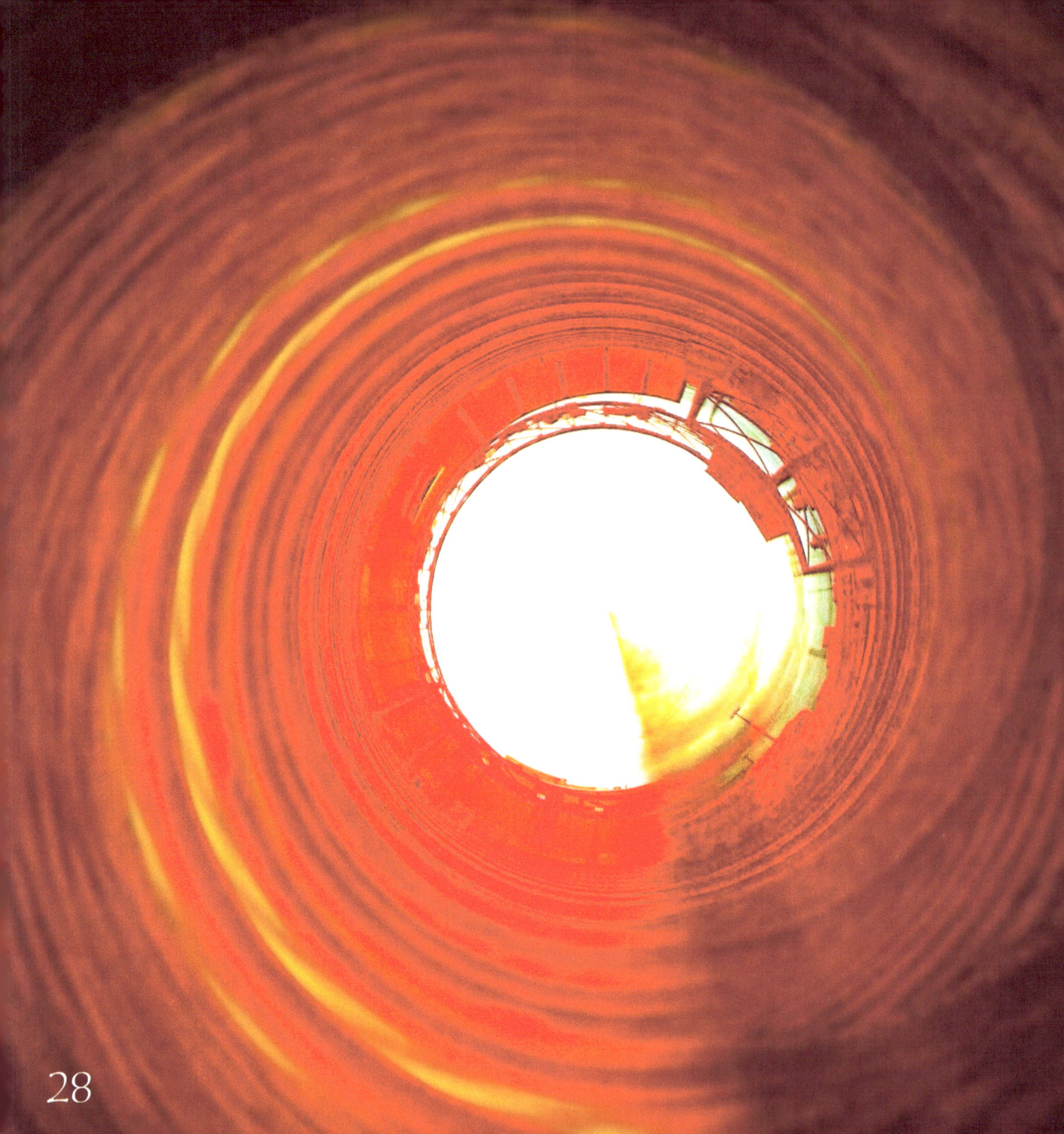

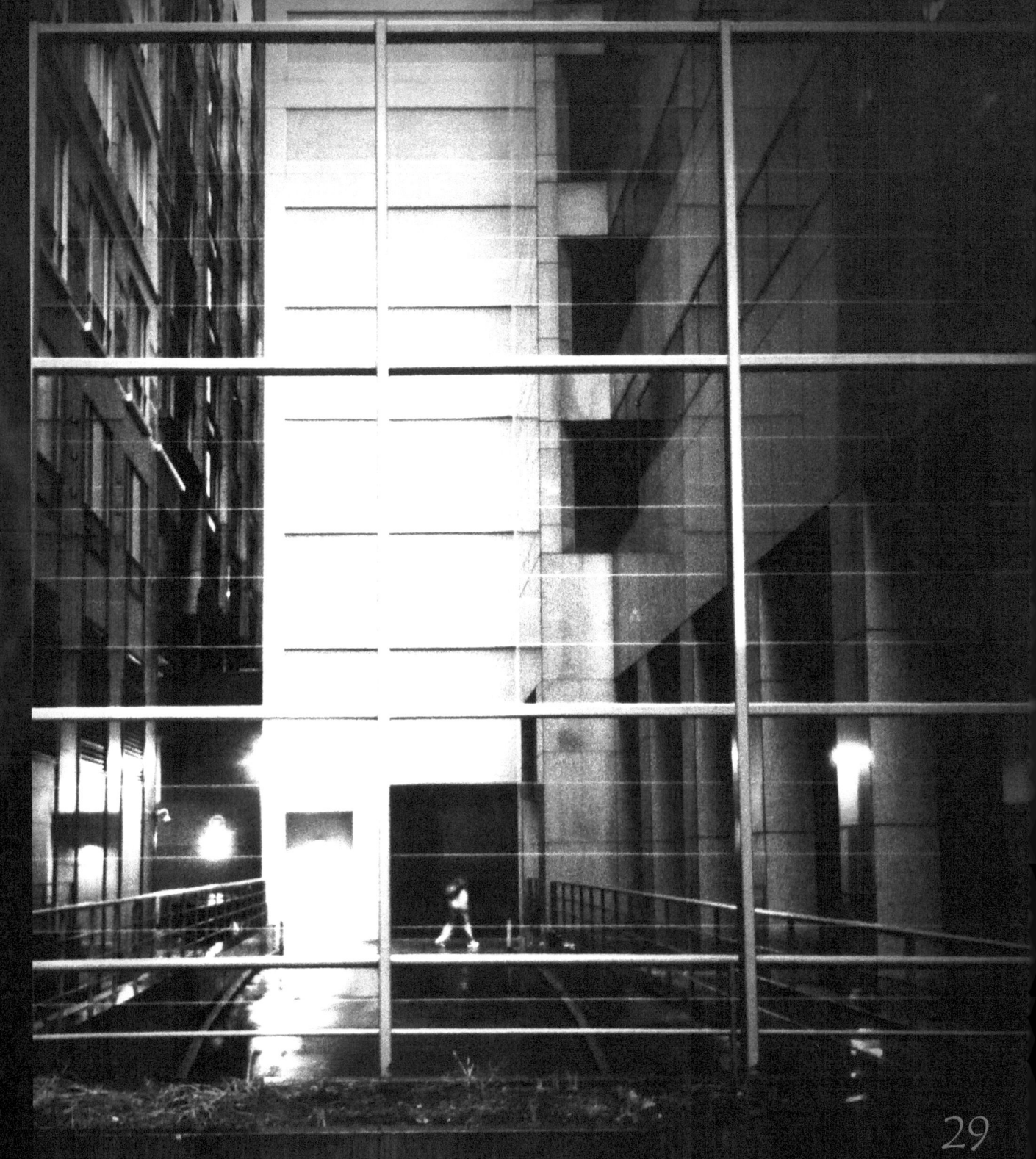

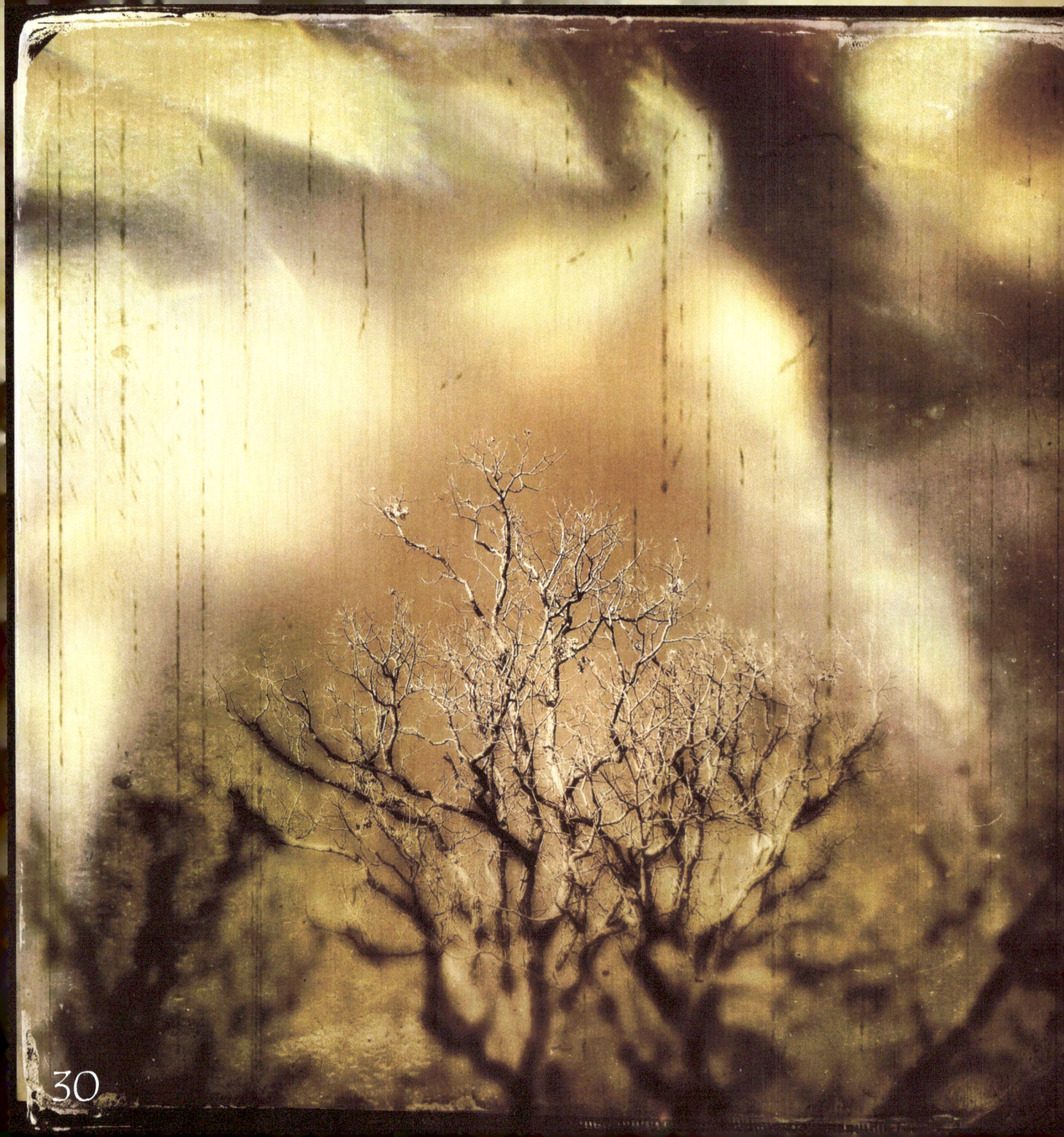

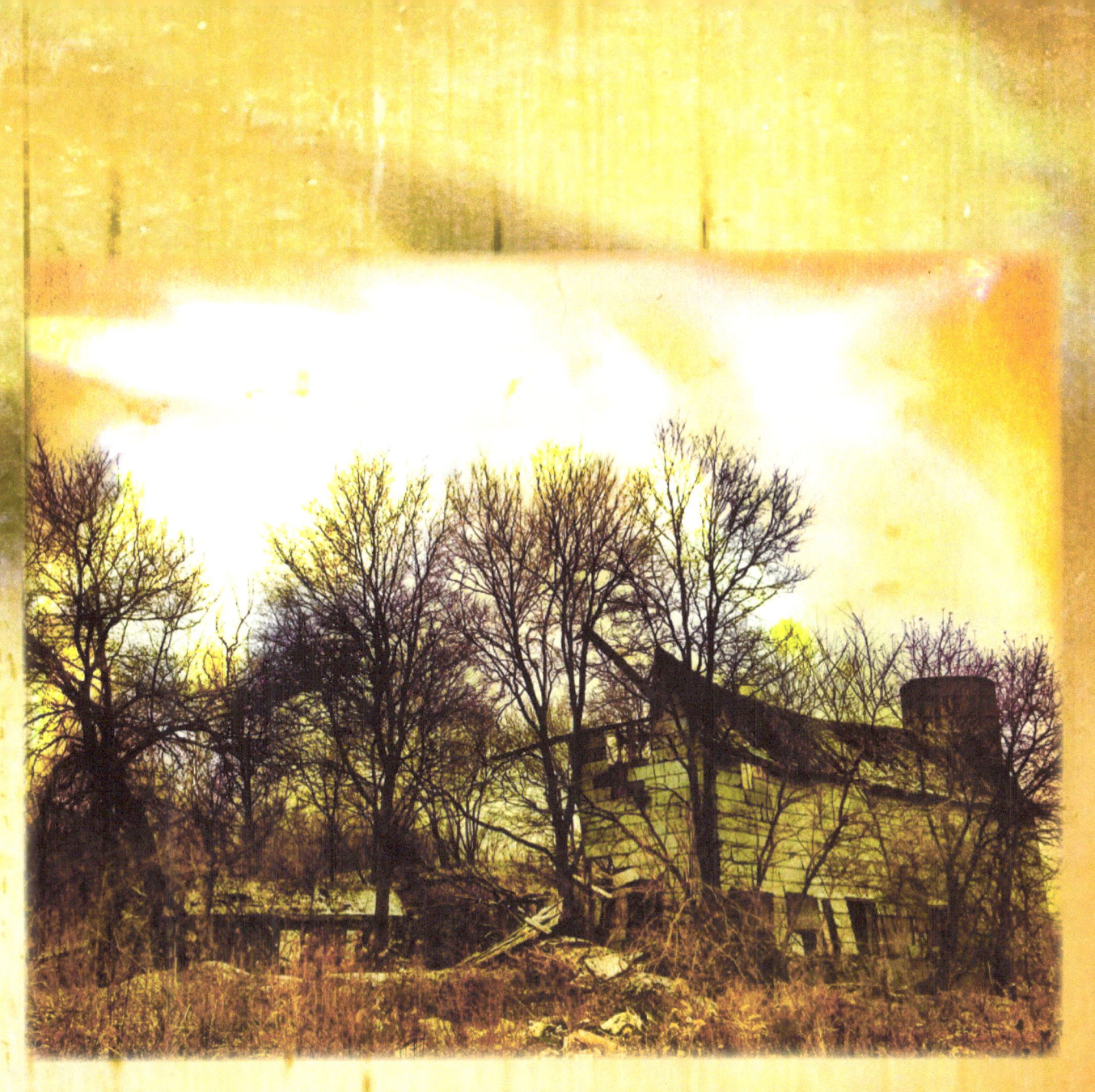

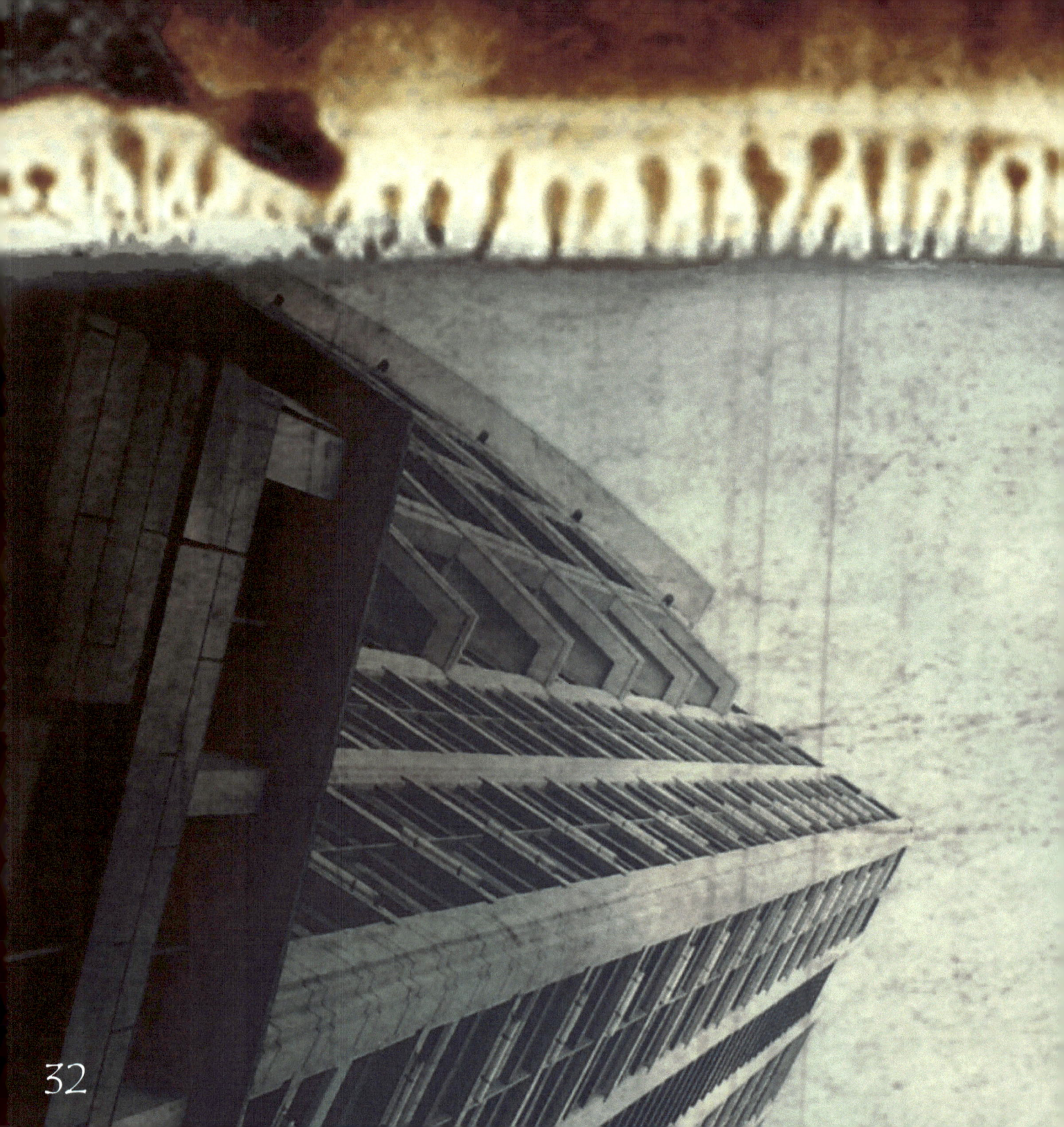

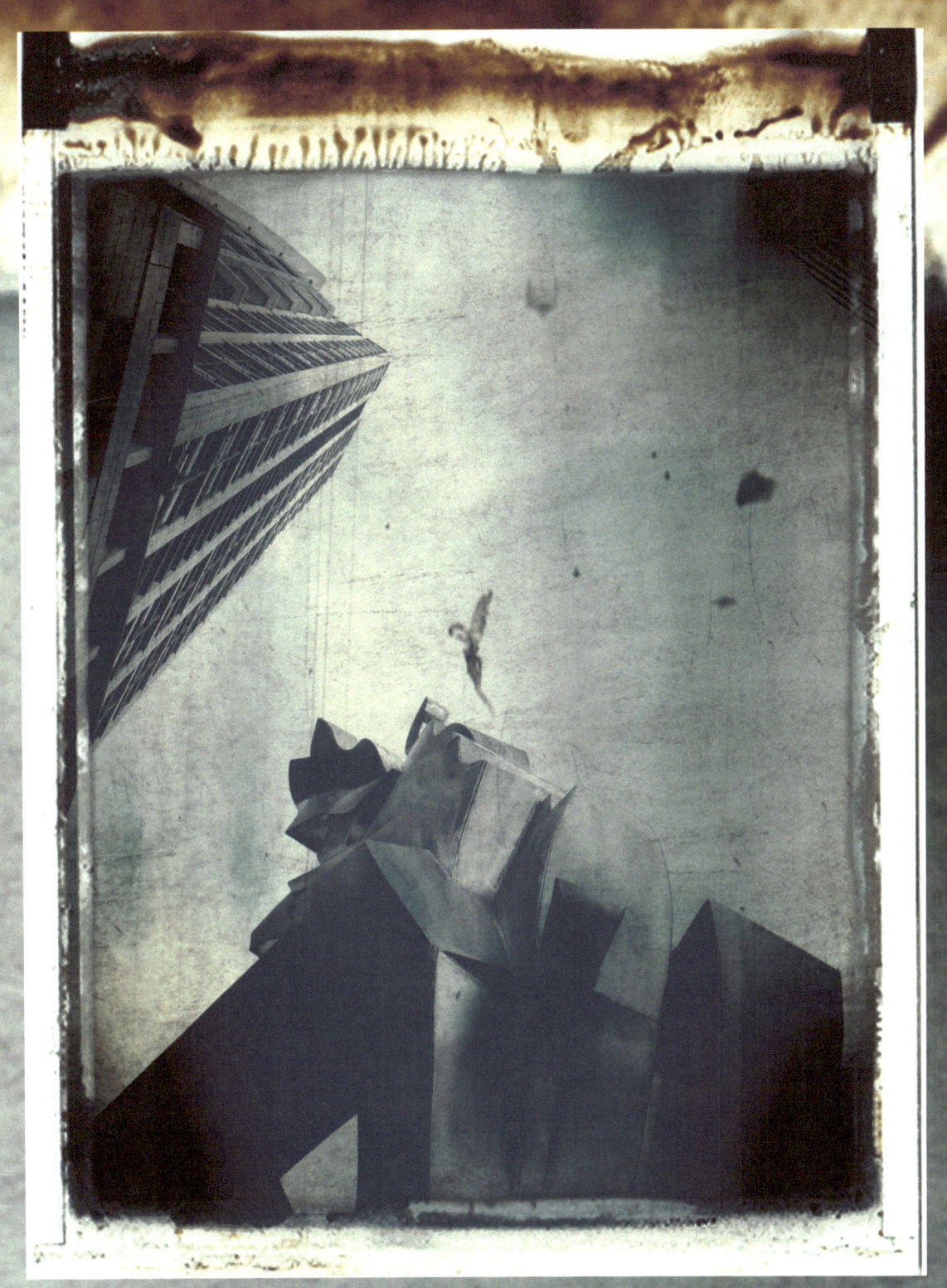

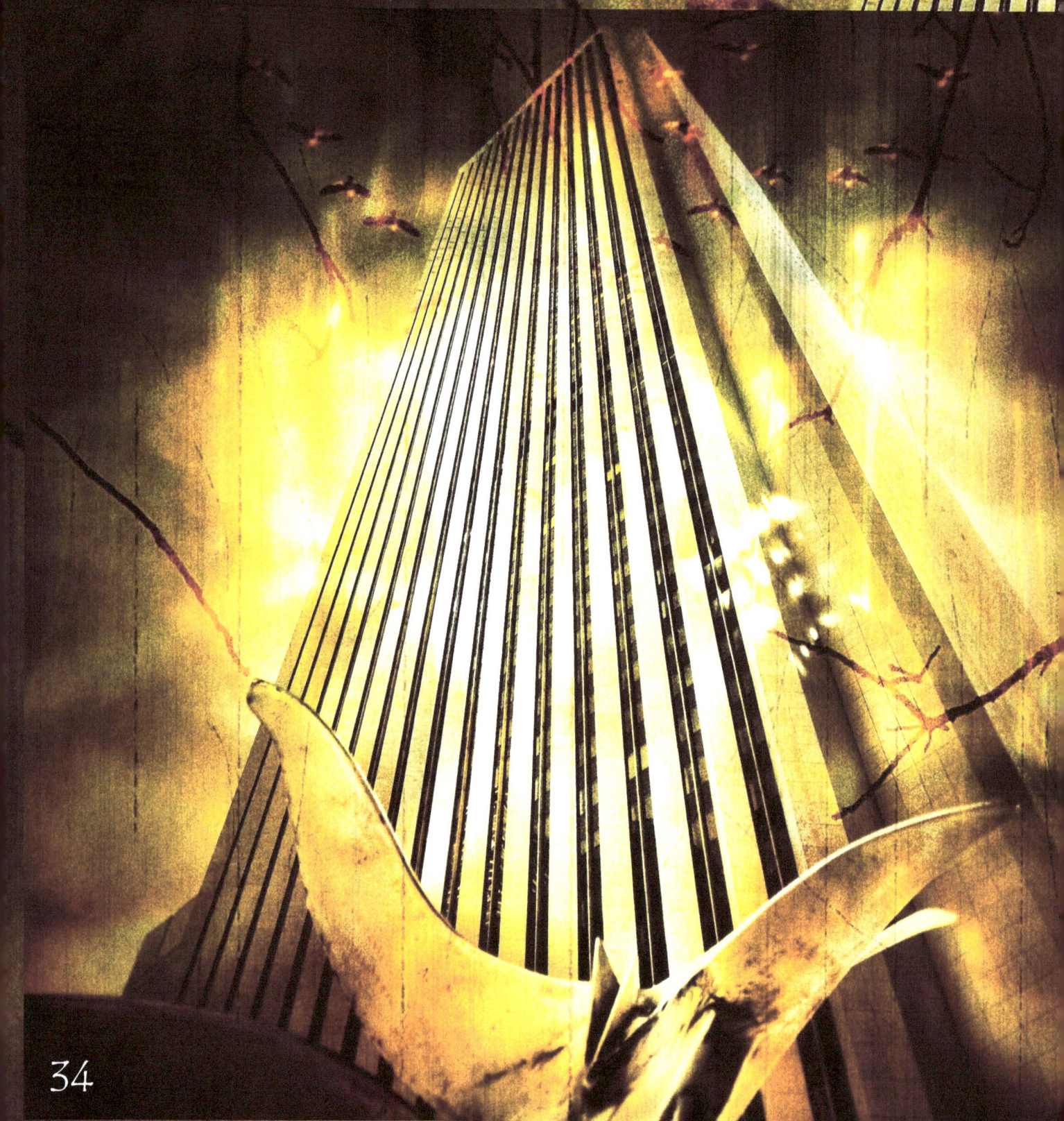

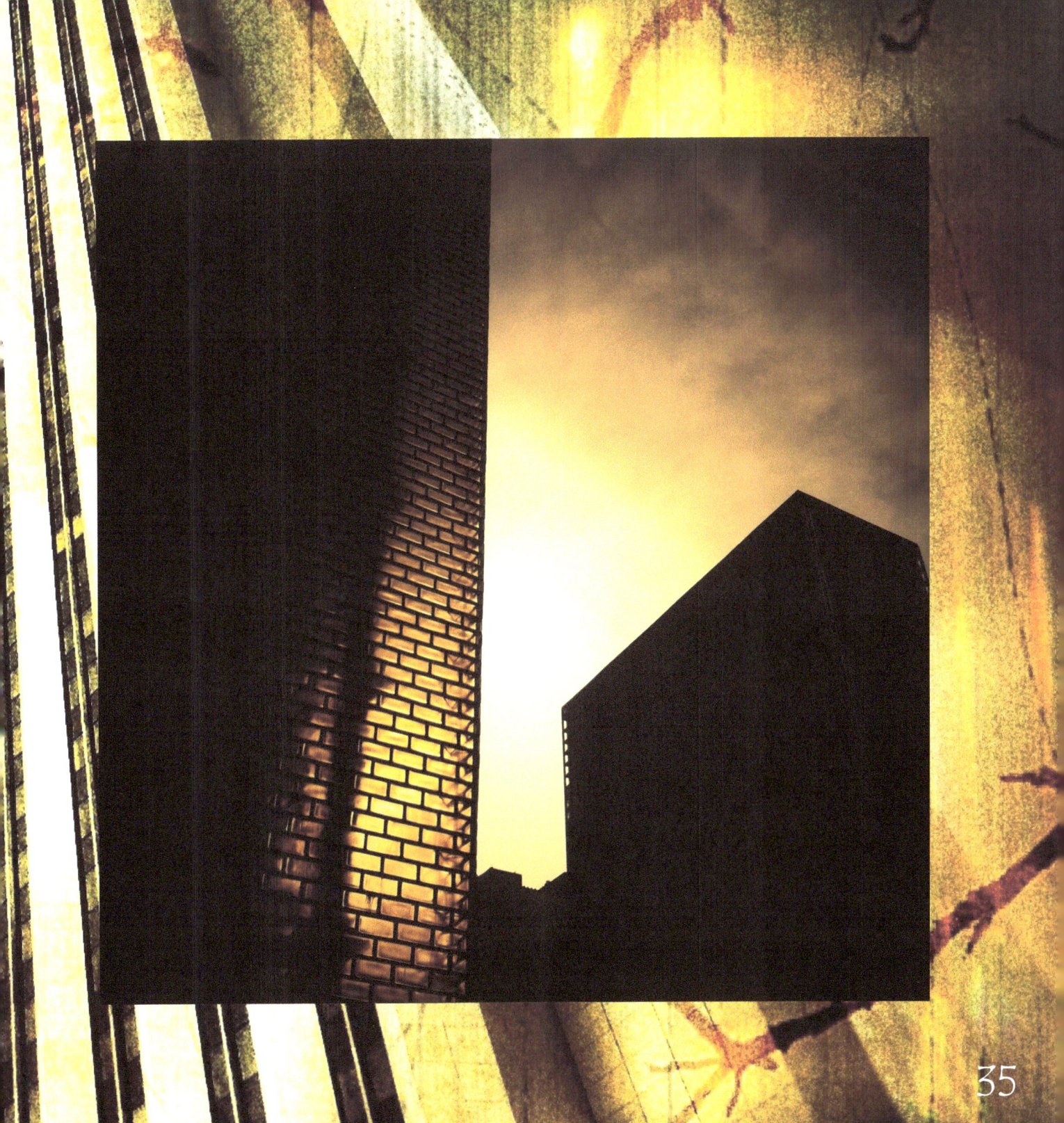

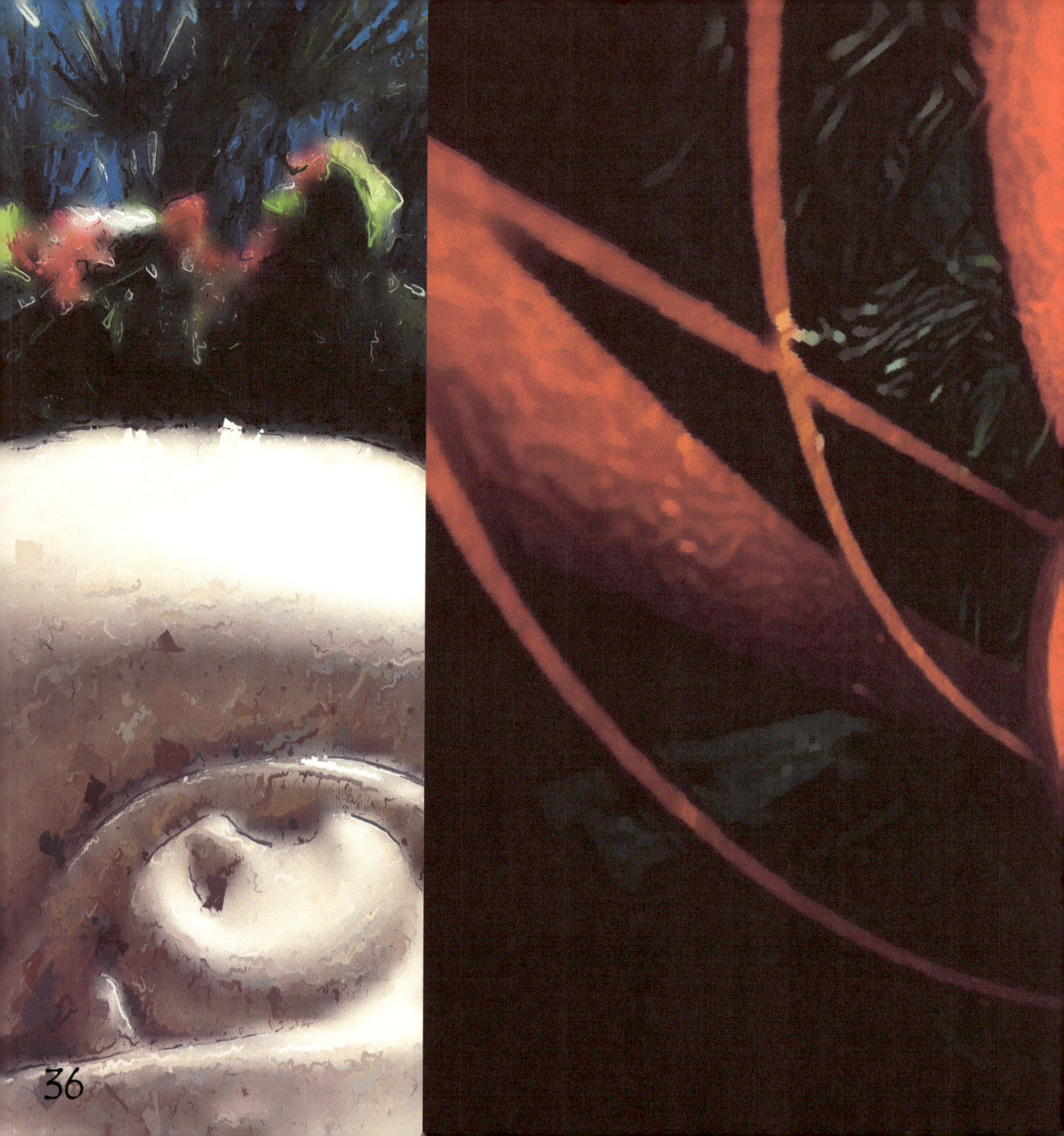

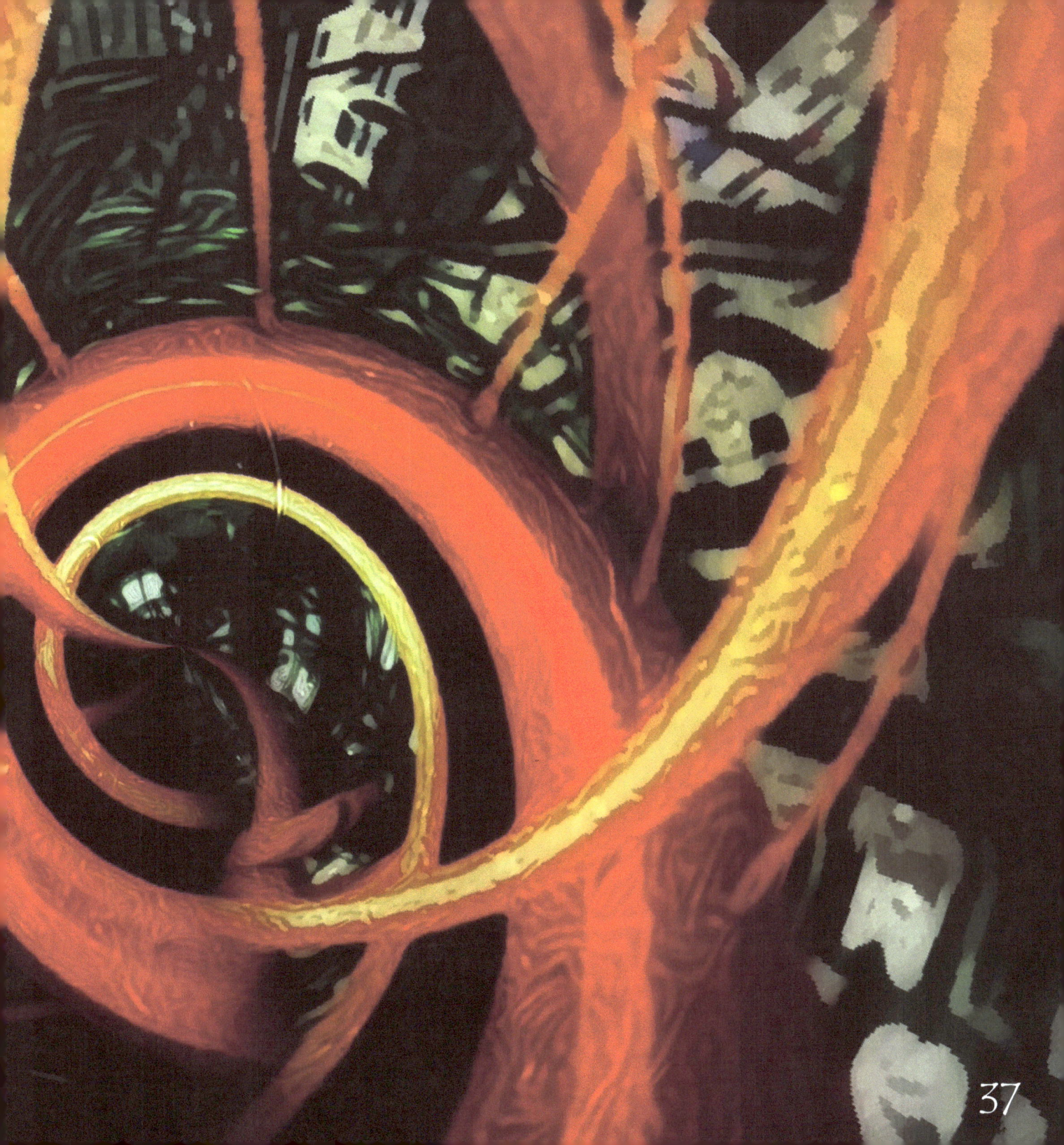

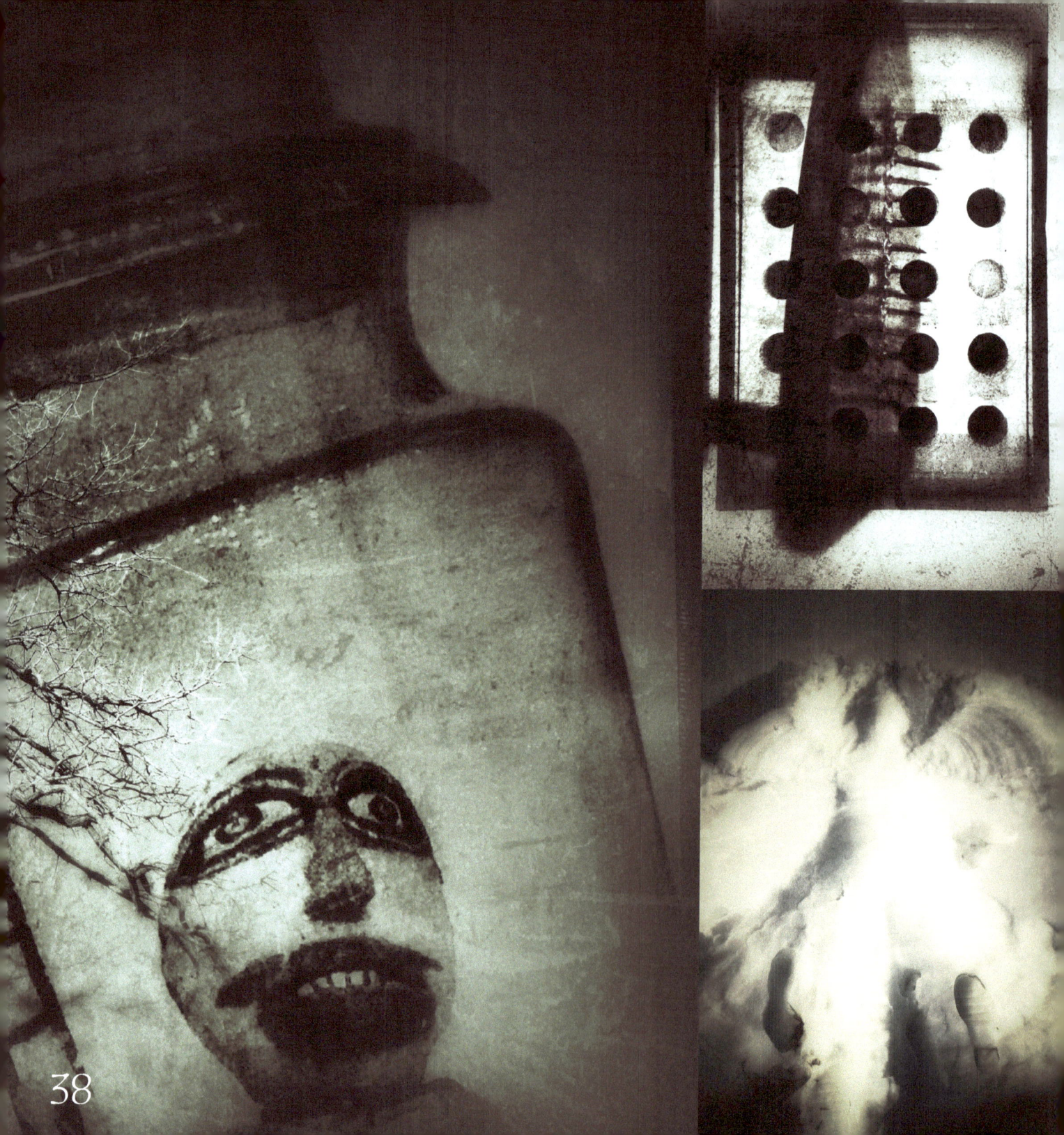

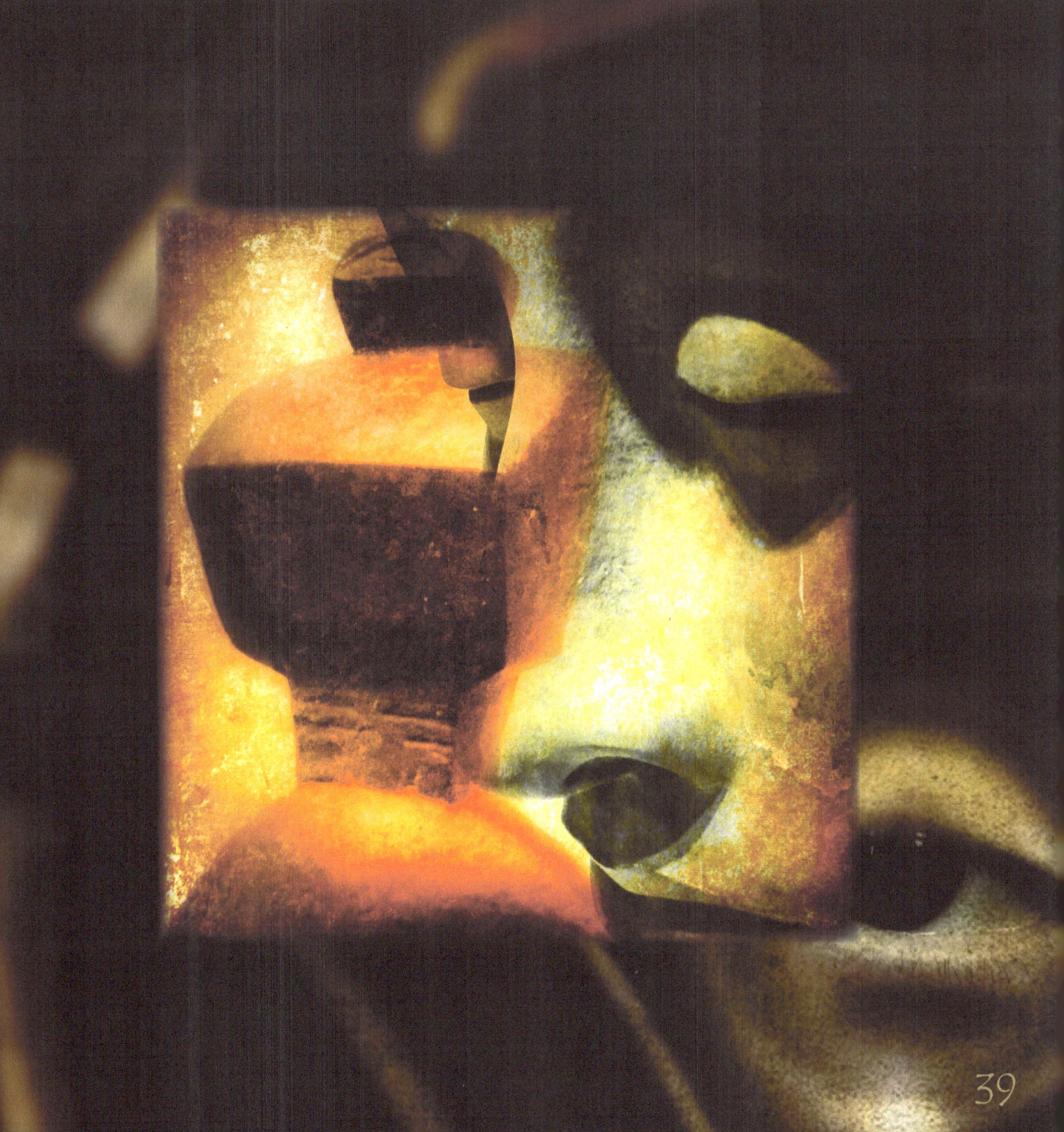

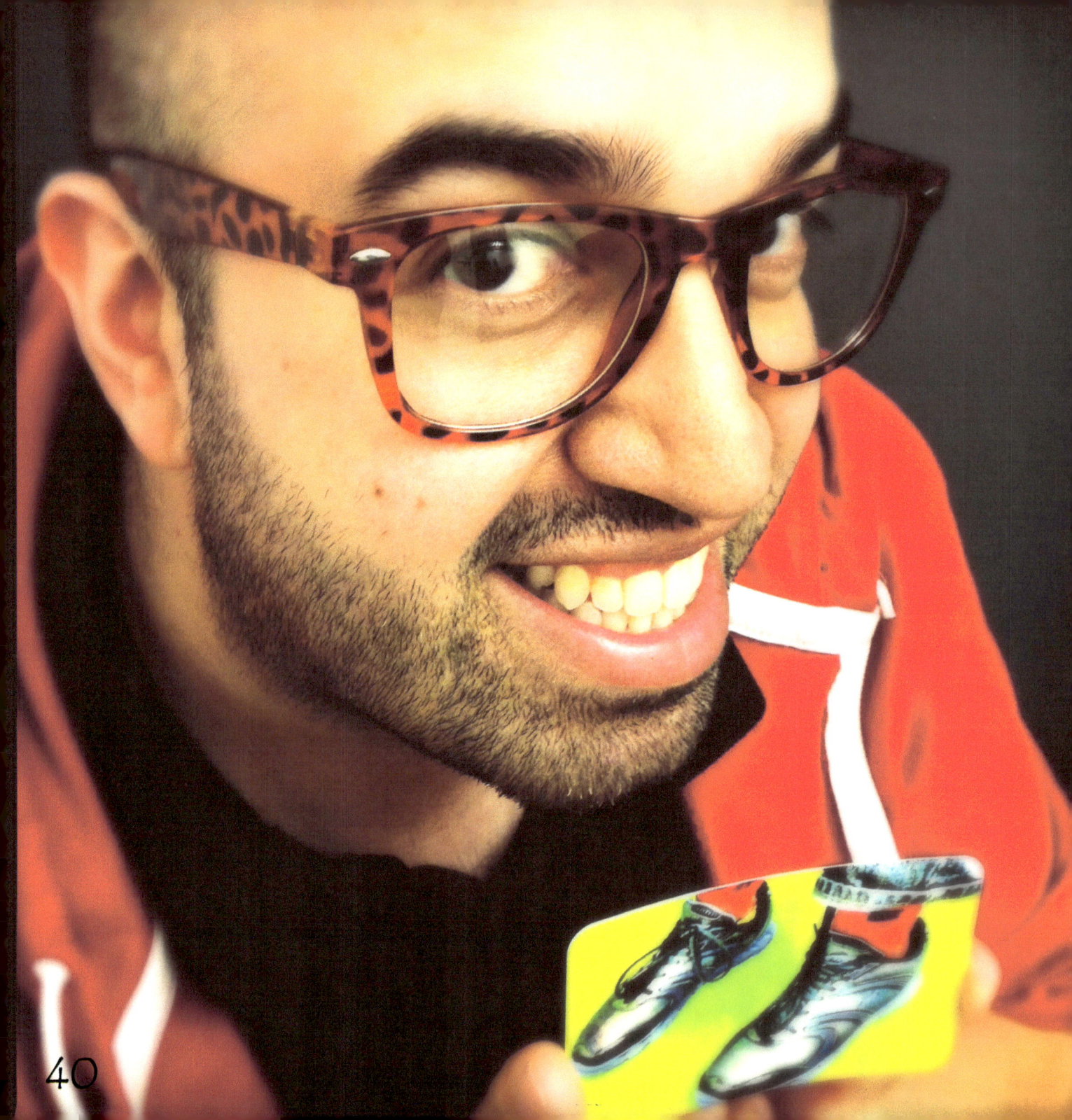

Joe's Sneakers
(& shoes & socks)

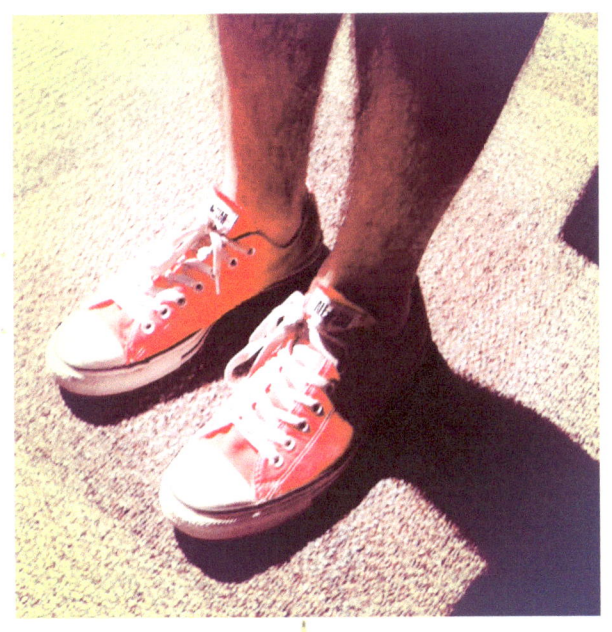

joe's sneakers

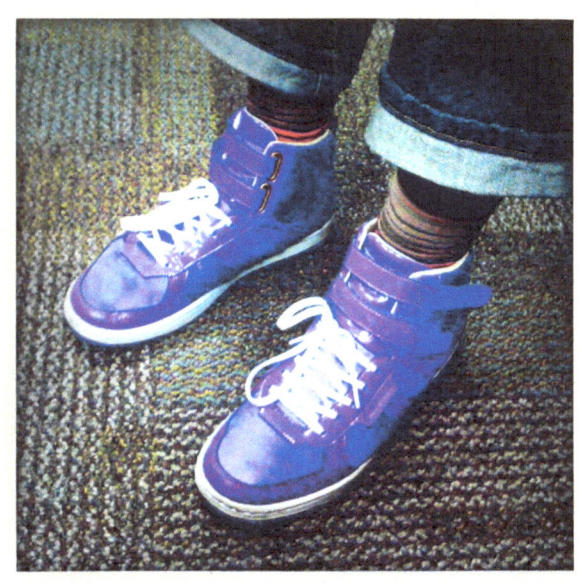

numero cuatro

my co-worker's eclectic footwear

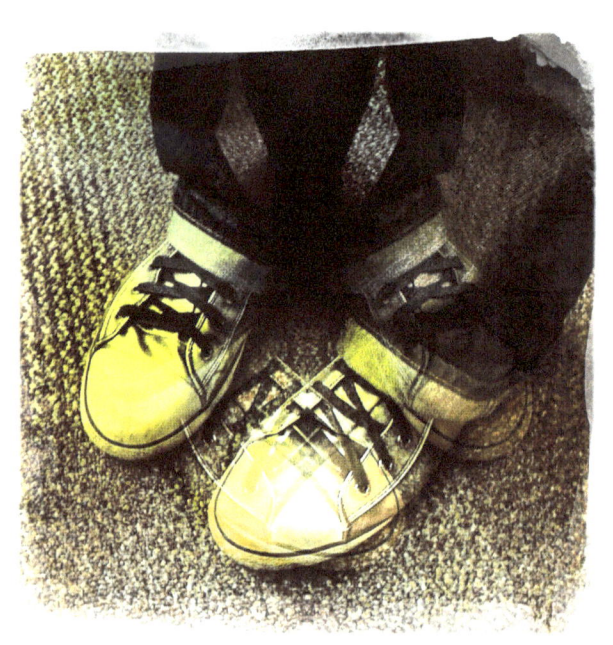

salvadorian seis

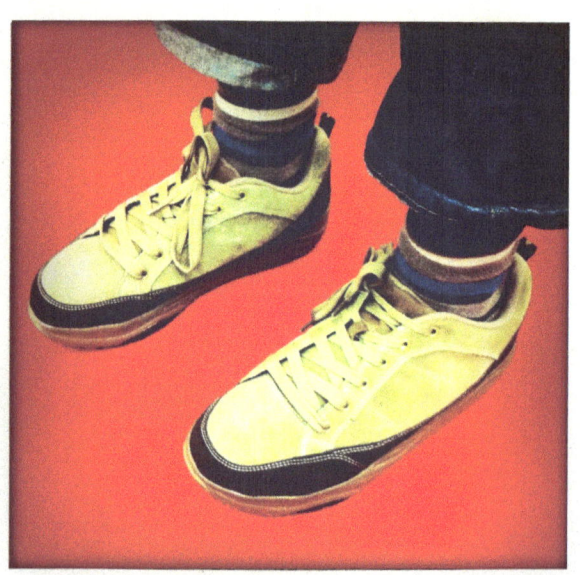

roca ocho

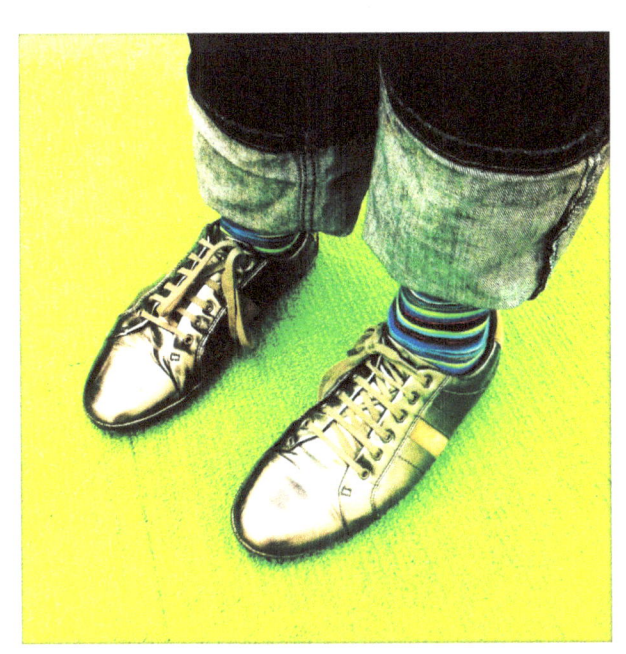

brillante diez

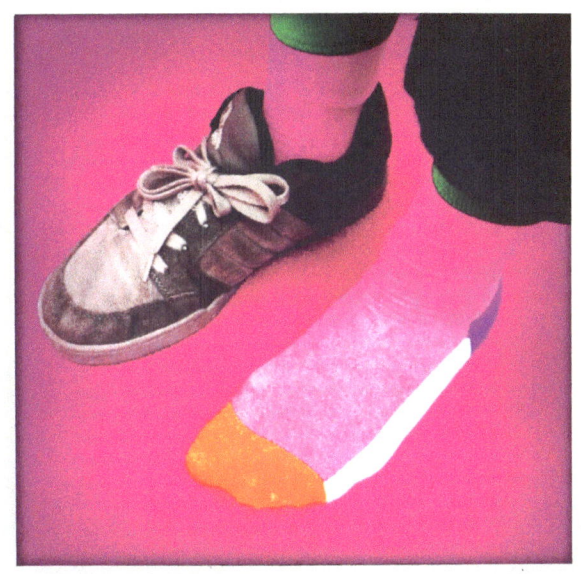

joe's sneaker... searching for a connection

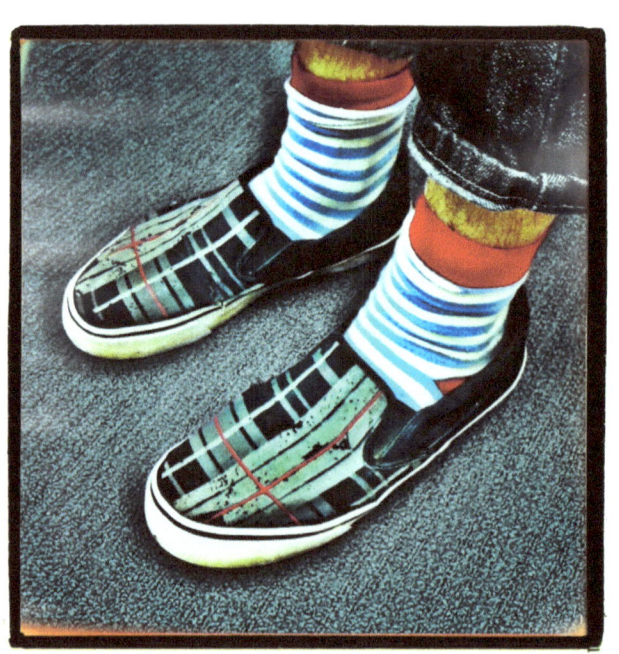

welcome back

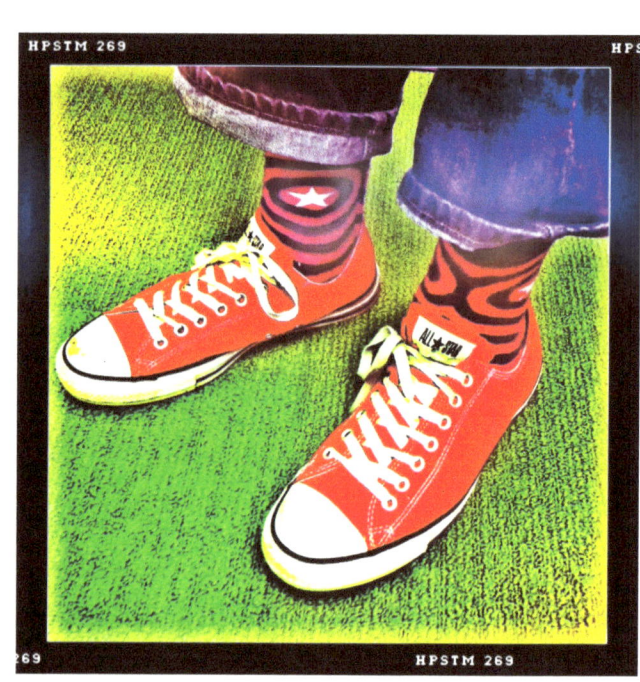

revisiting red

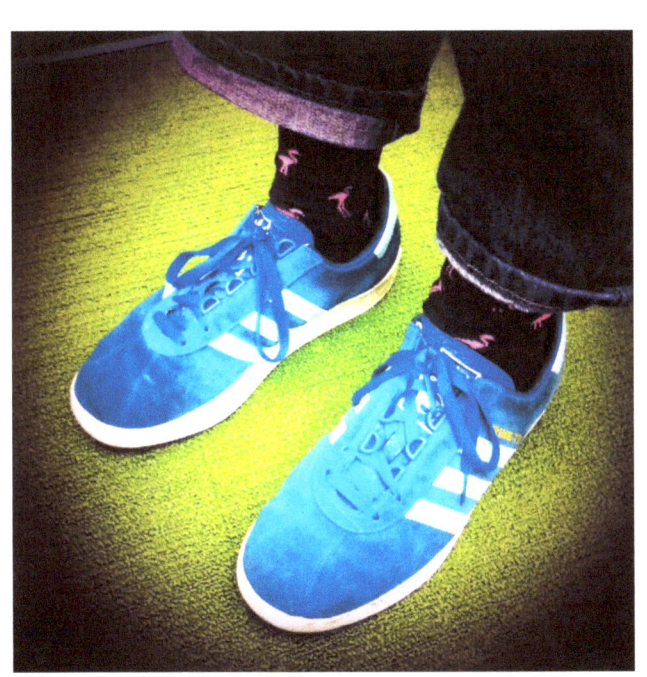

lomo flamingo

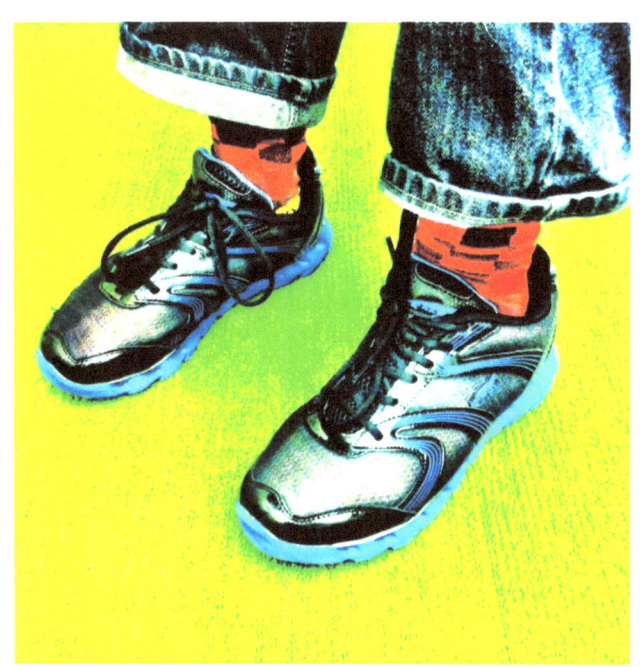

catapult cinderella

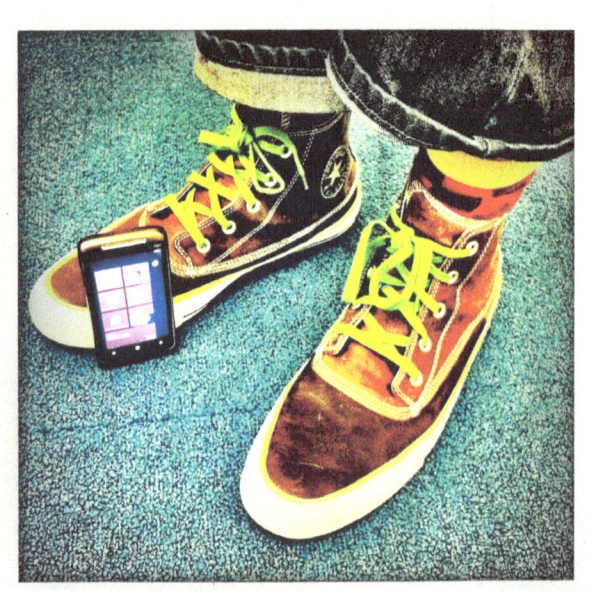

windows edition

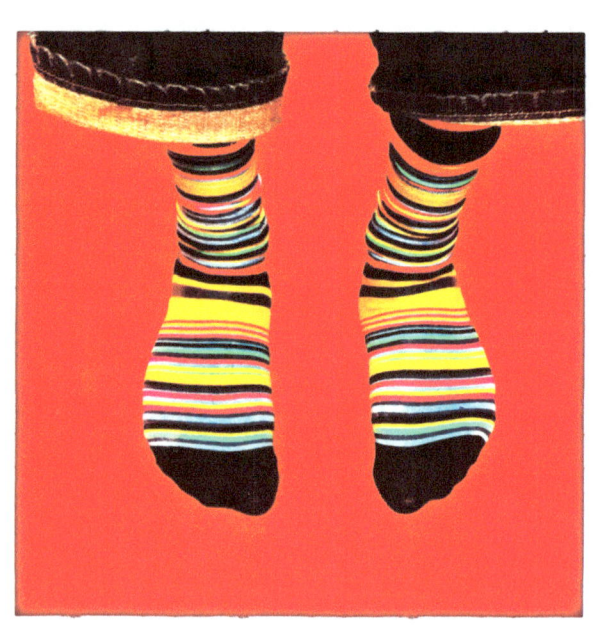

joe's... socks!

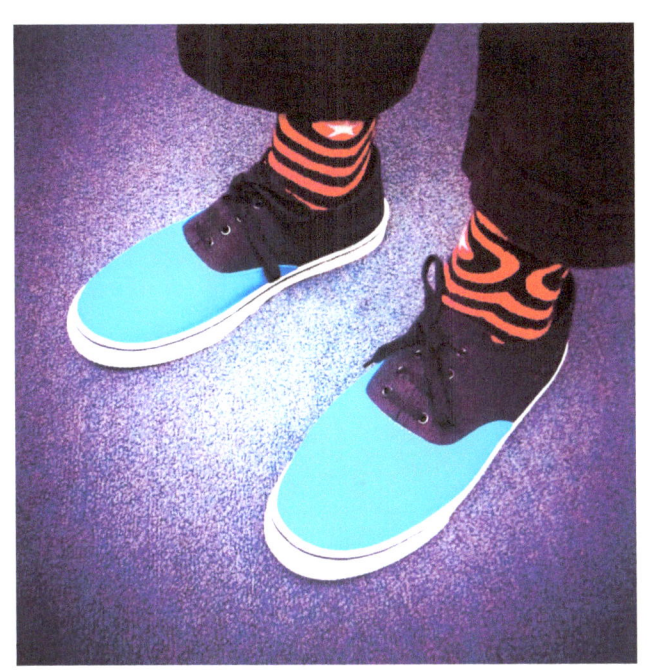

forever 21

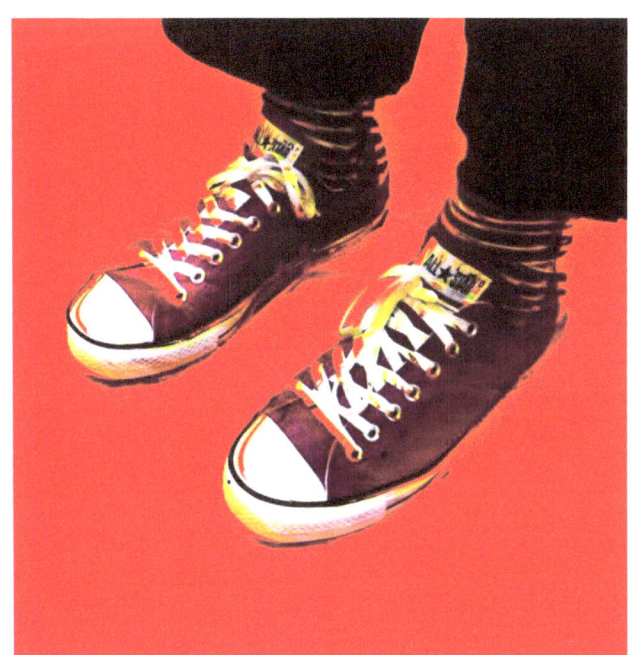

shaking all over

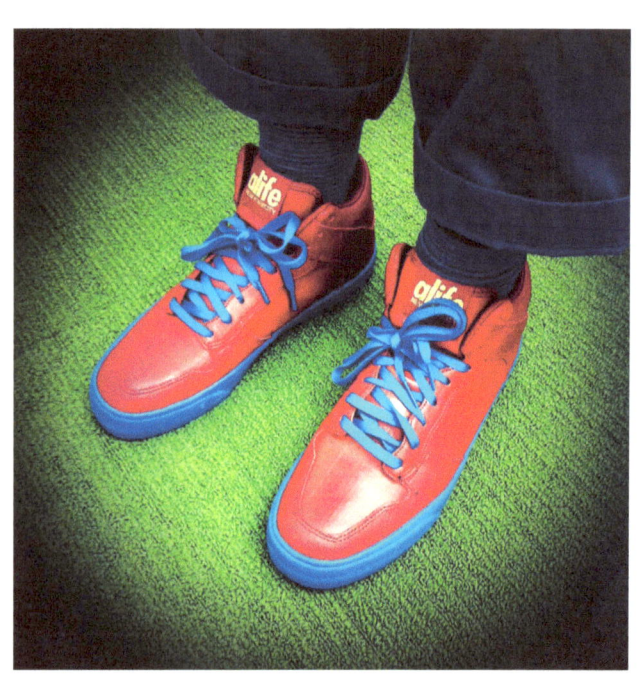

it's alife!

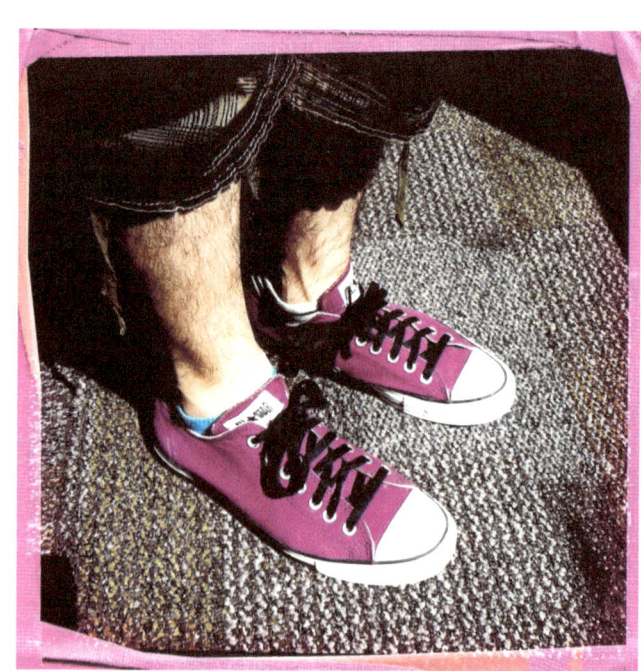

big up summertime!

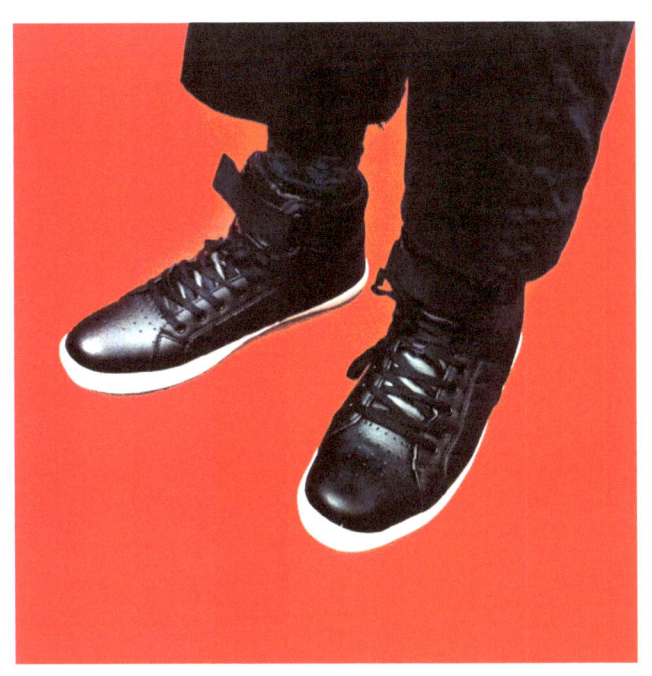

walking on clouds

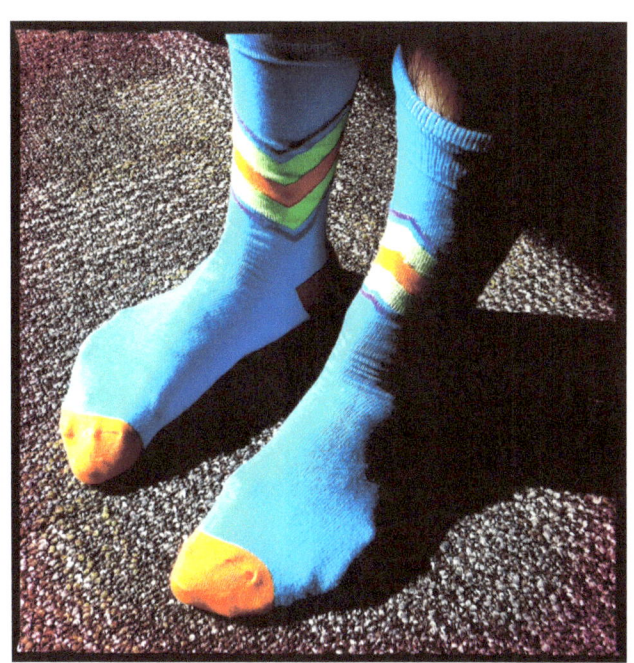

joe's socks... special fall edition

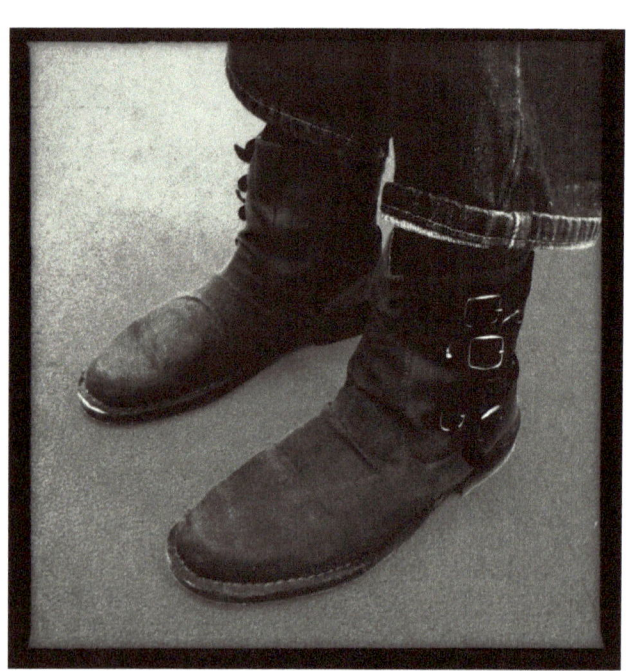

joe's boots... and buckles

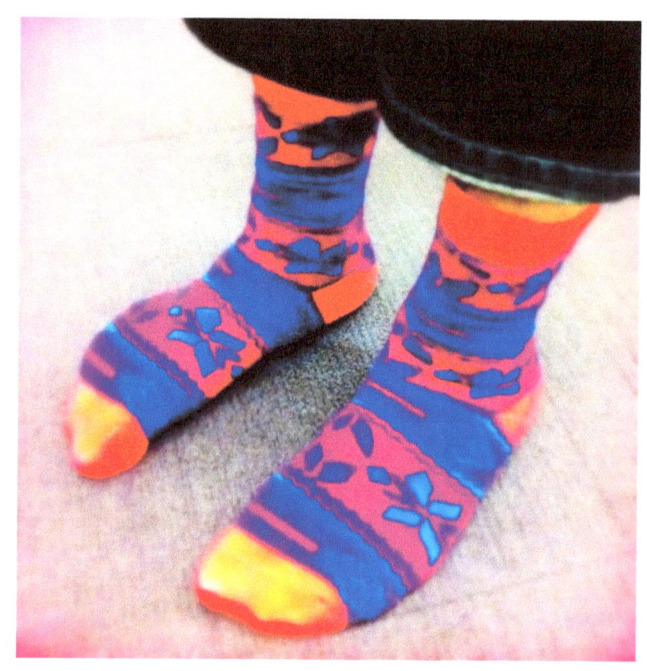

joe's socks... psychedelic!

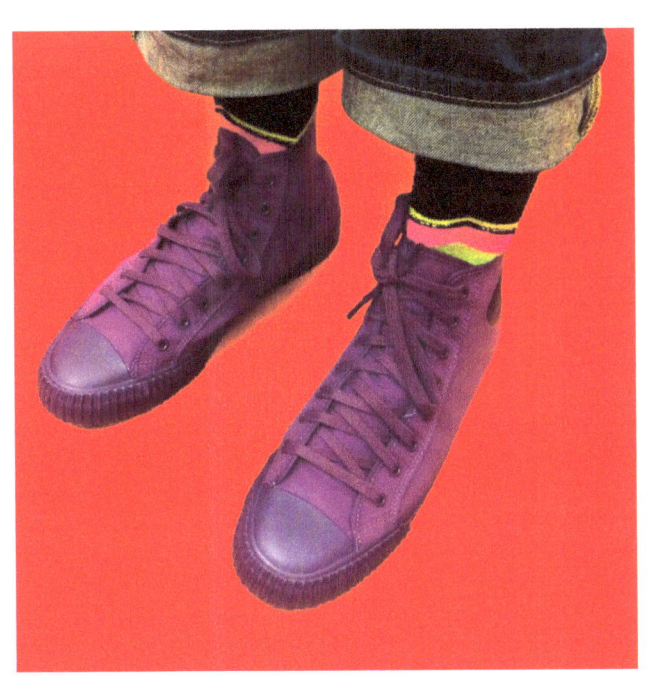

purple people eaters

joe's socks... warm & fuzzy

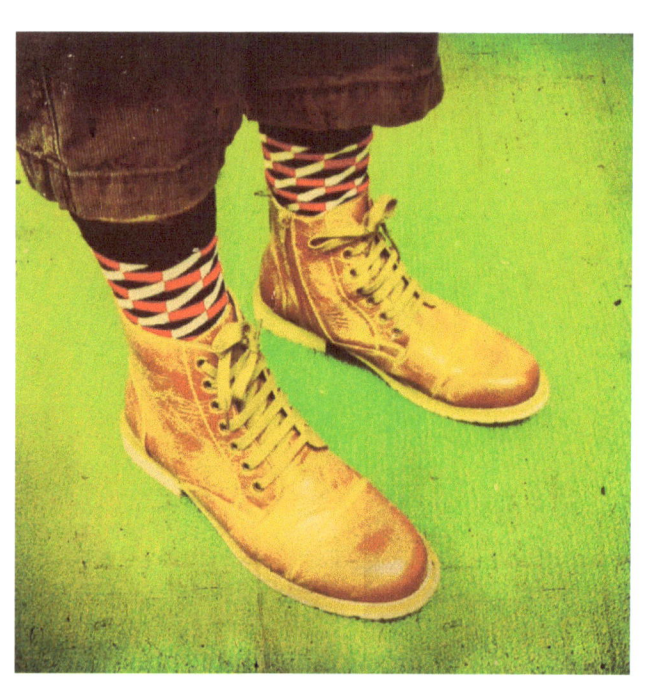

joe's shoes... kickin it old school

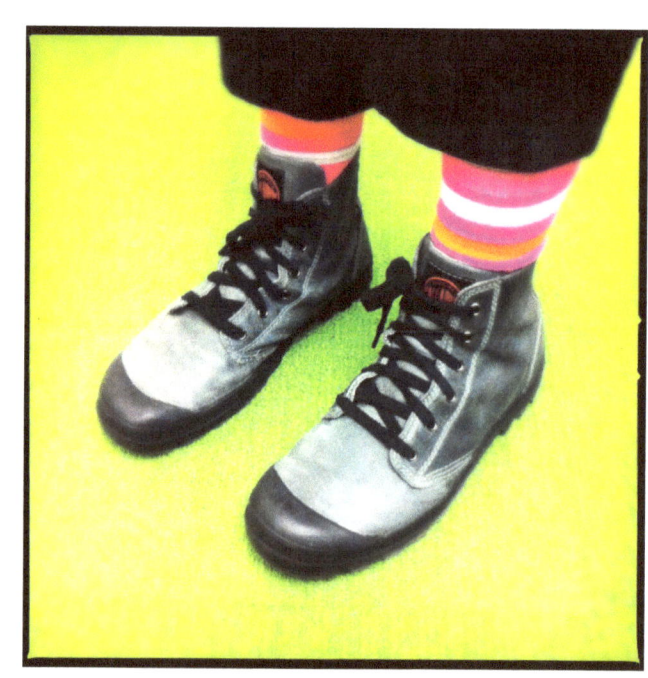

joe's sneakers, comfortably urban

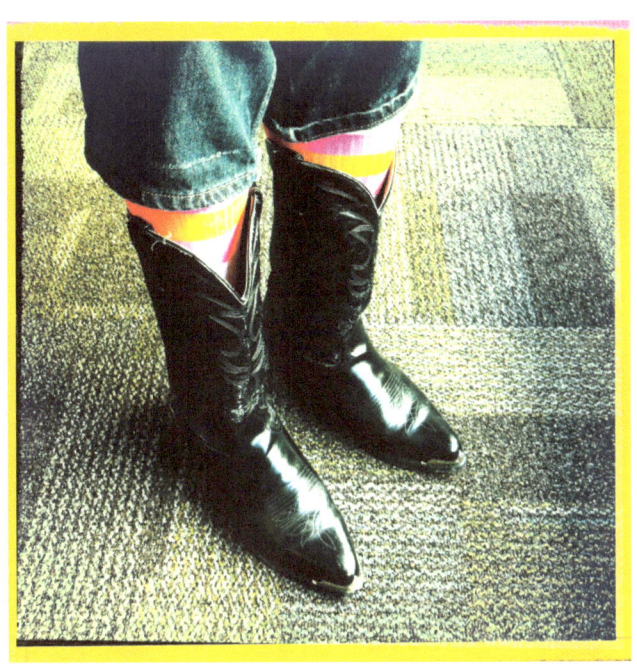

joe's boots - steel toe texan

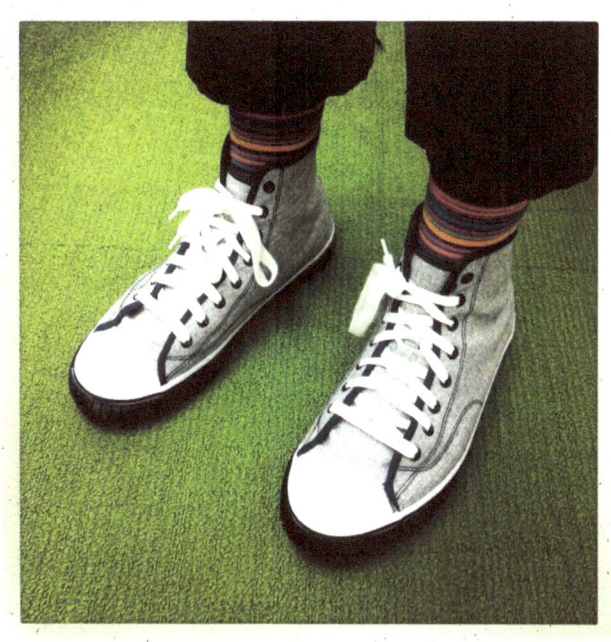

joe's sneakers, summer of airwalks

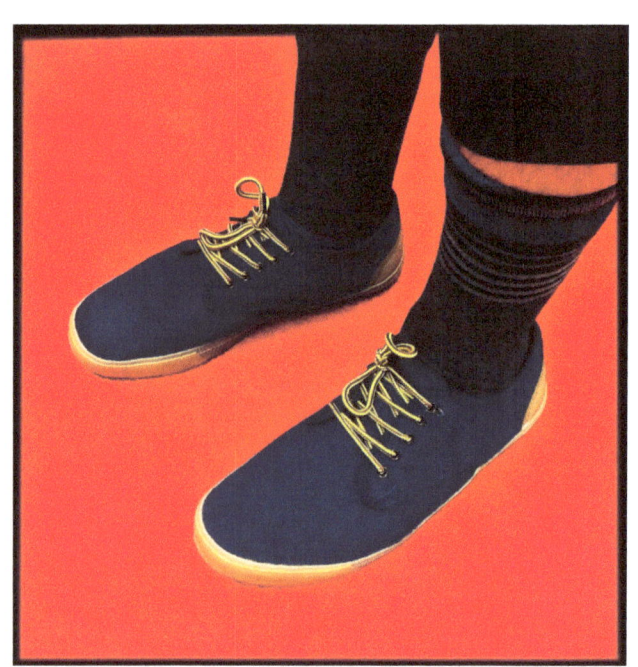

foxy sugar blues

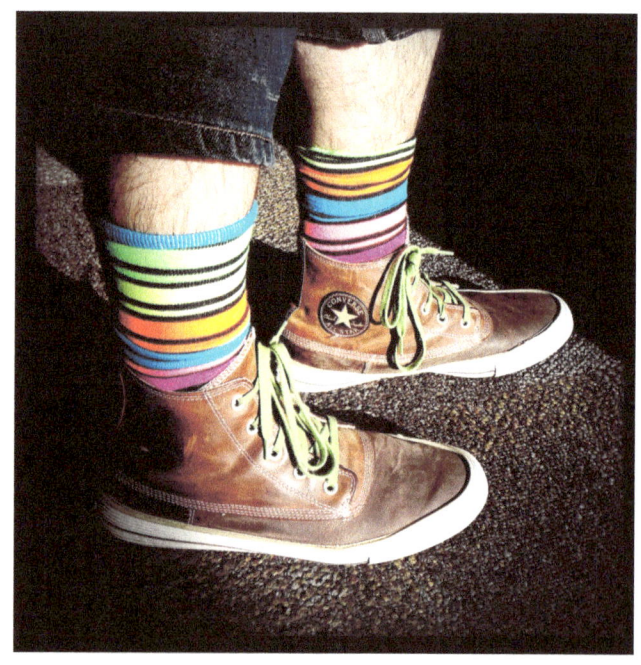

joe's sneakers, iPhone 5 edition

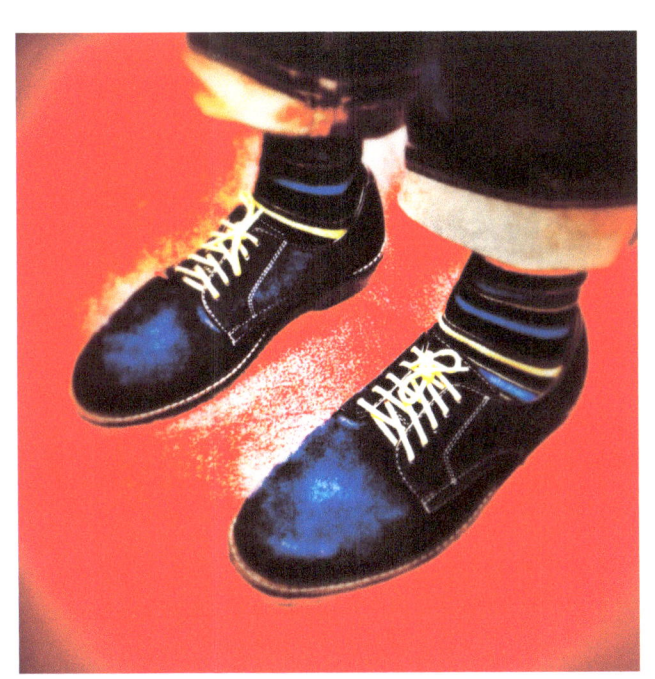

joe's shoes, hot tamale

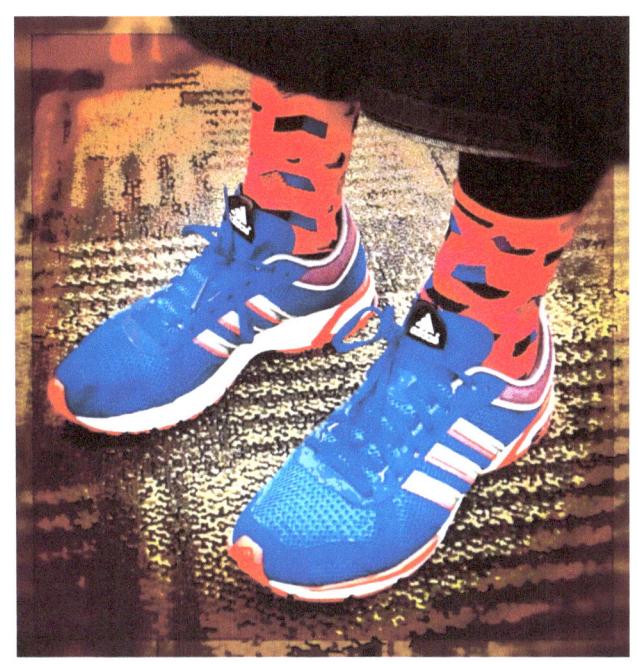

multiplied

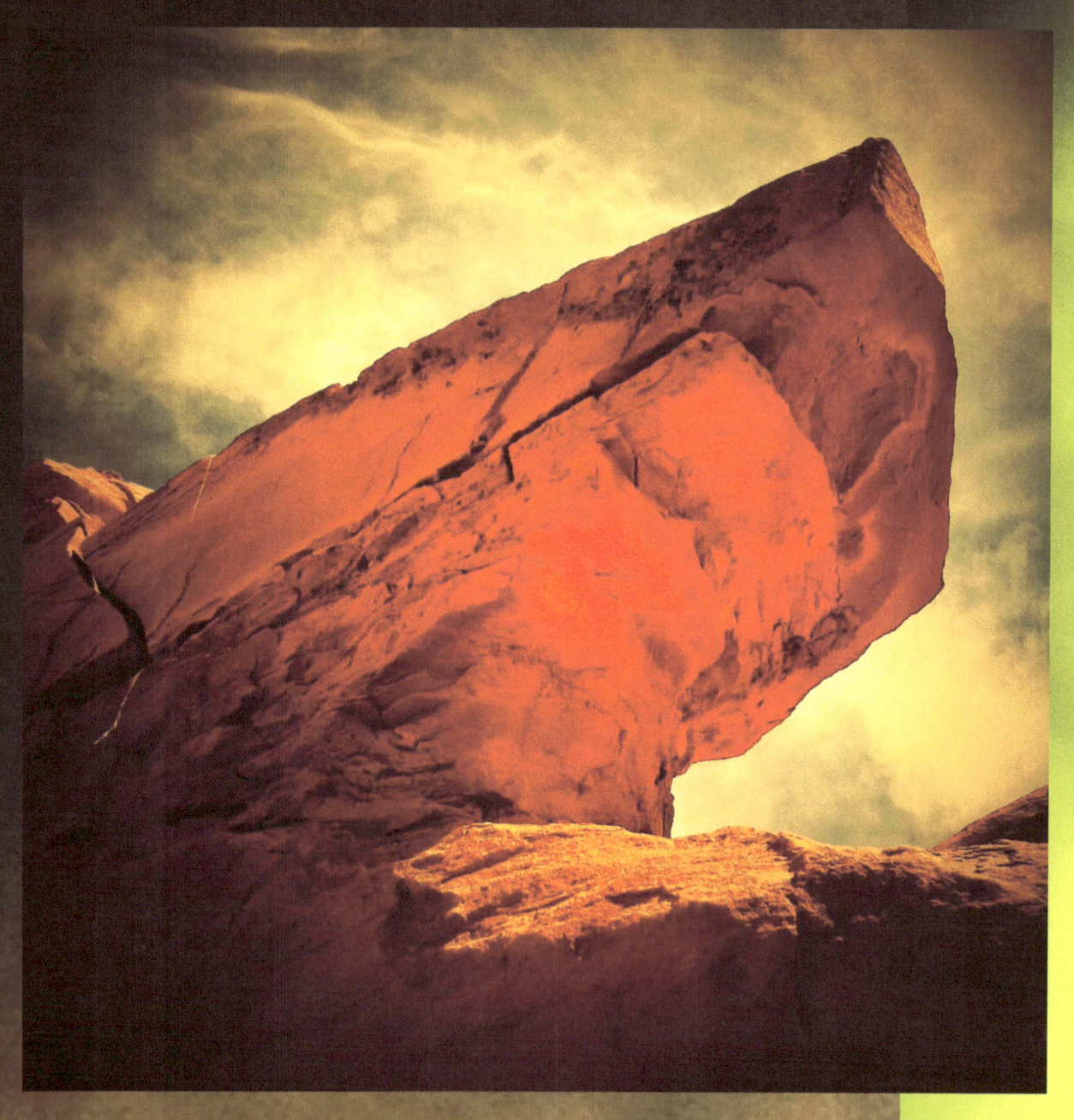

sky shots

Photo Listing: (56) chasing majestic (57) form in the sky (58) hovering (59) dylan's heaven; elevation (60-61) reaching for nacho (62) armenia city in the sky (63) lock is the tree (ode to edina) (64) a connecting principle (65) acroteria (66-67) my early morning (68) more songs about buildings and food (69) seconds of pleasure (70) john ford's canvas (71) big up winter; sunday ballooning (72) stay here in this moment (73) outer space experiences (74-75) flamenco revisted; my city was gone

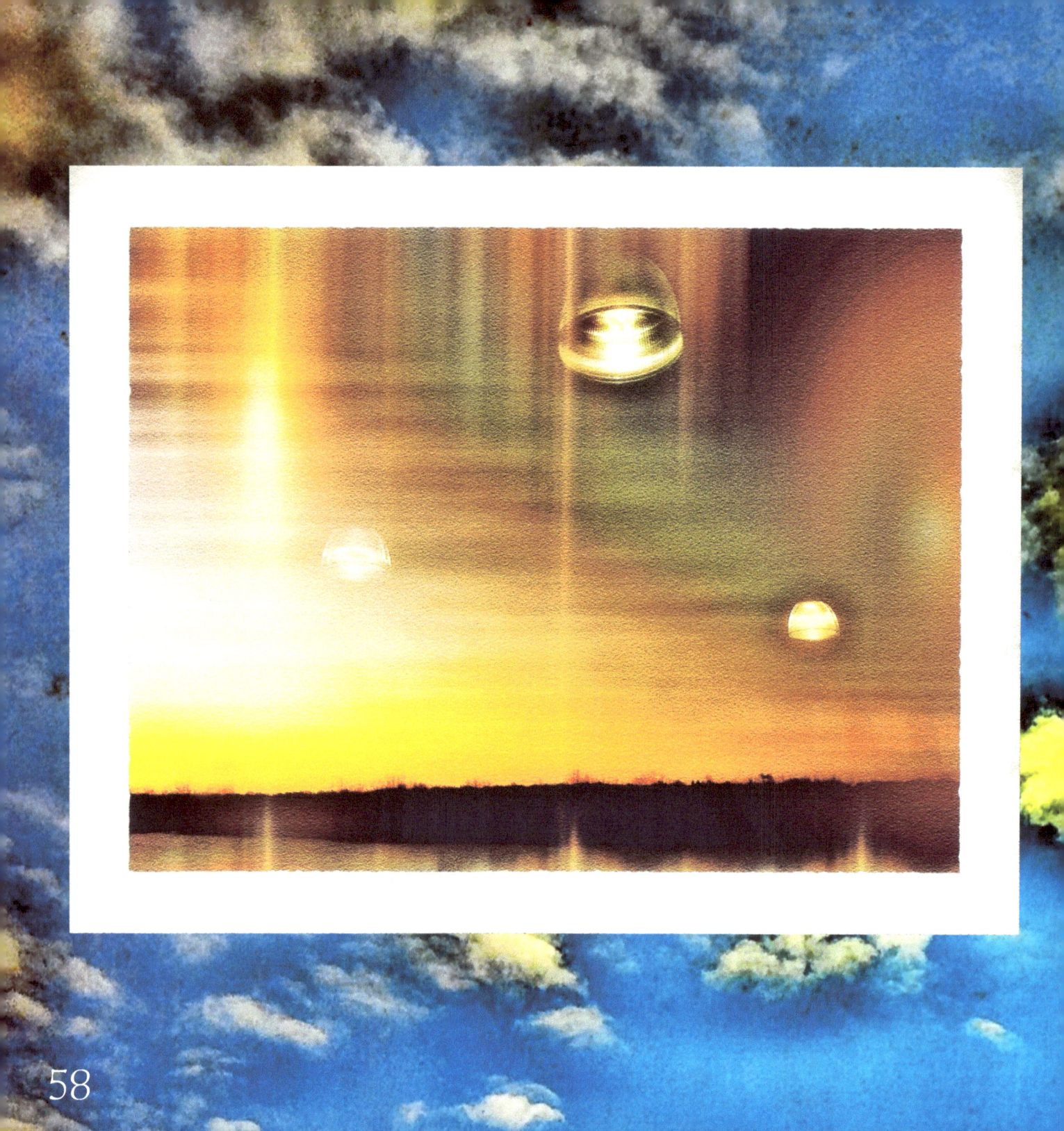

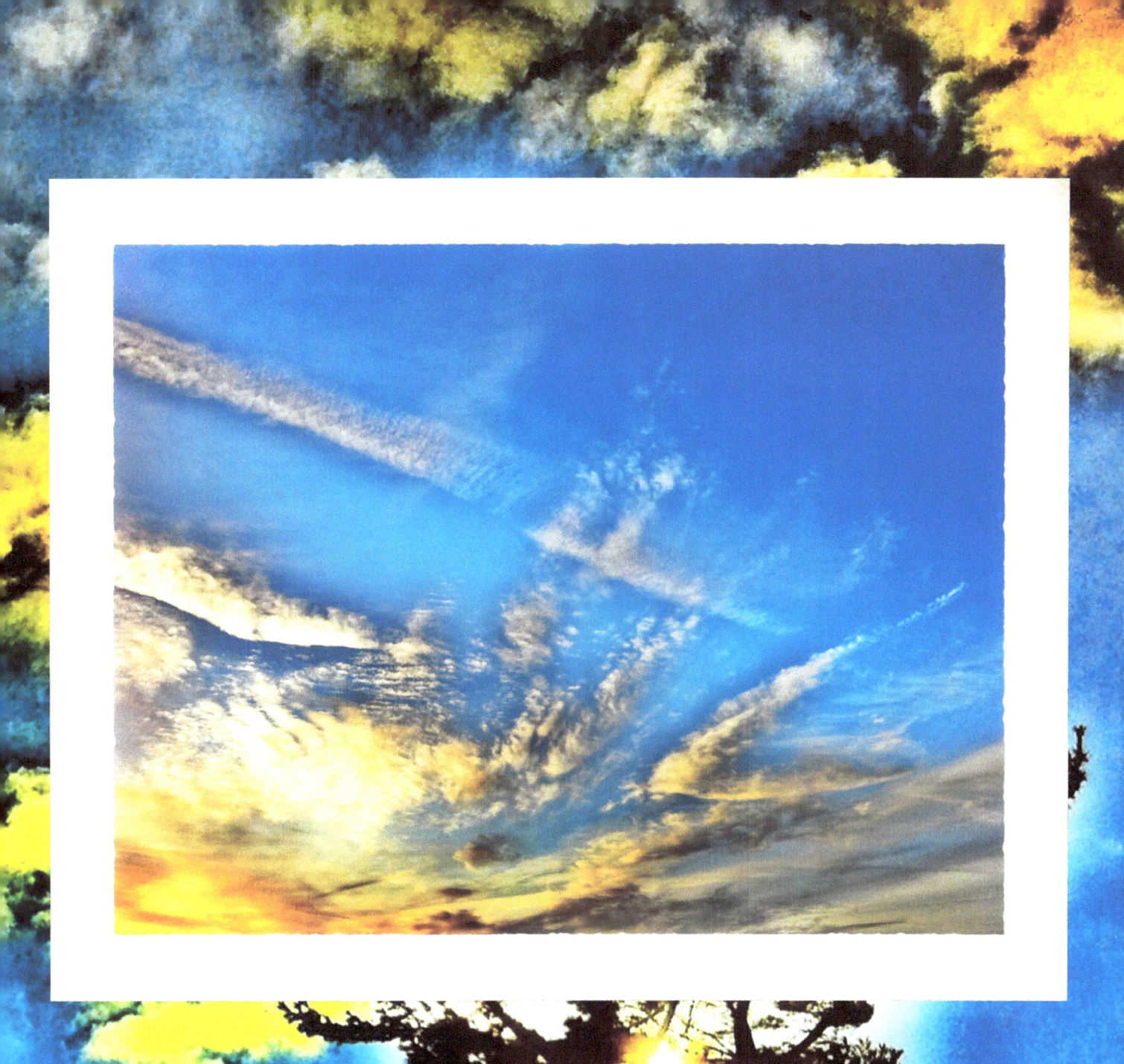

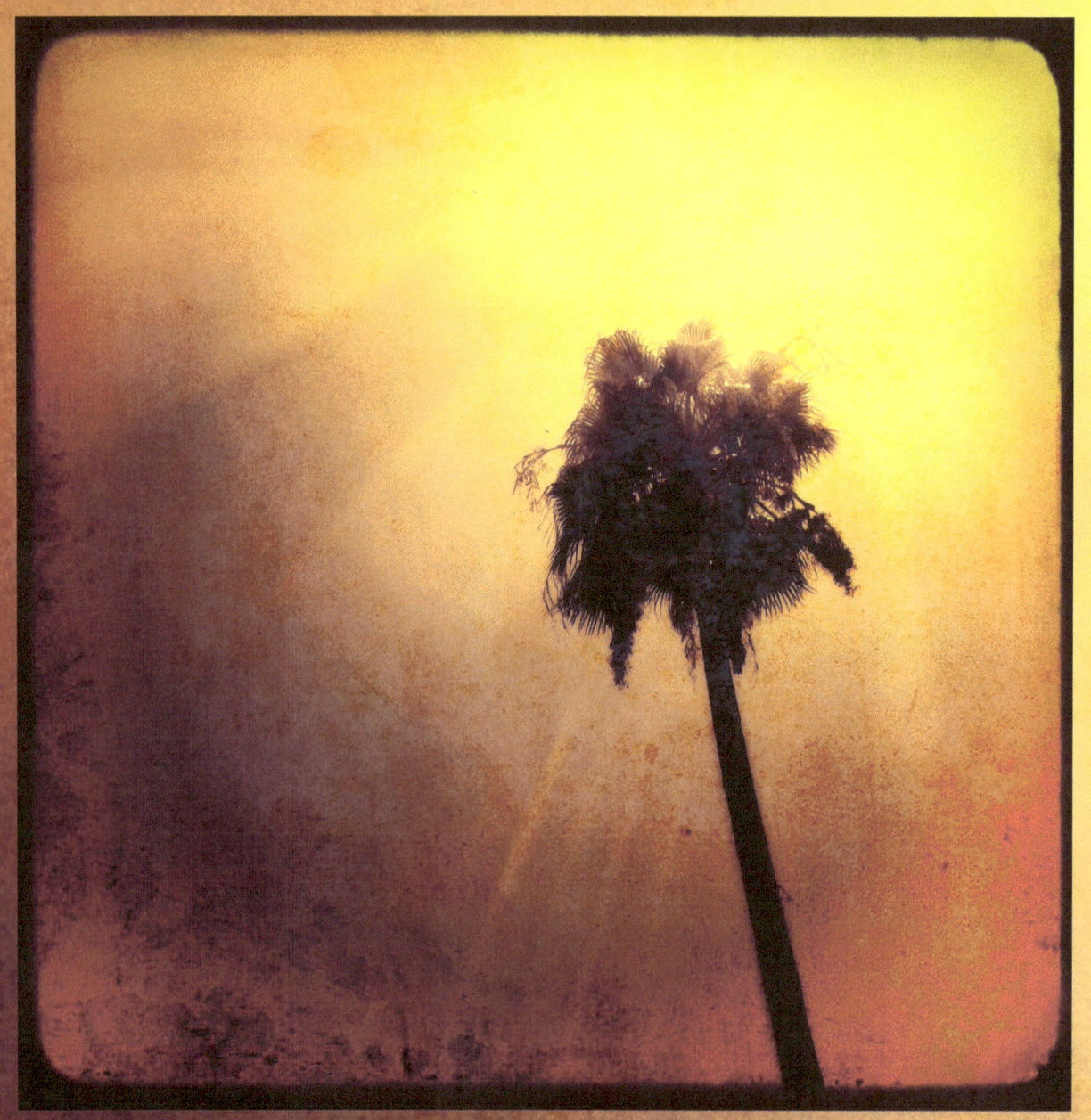

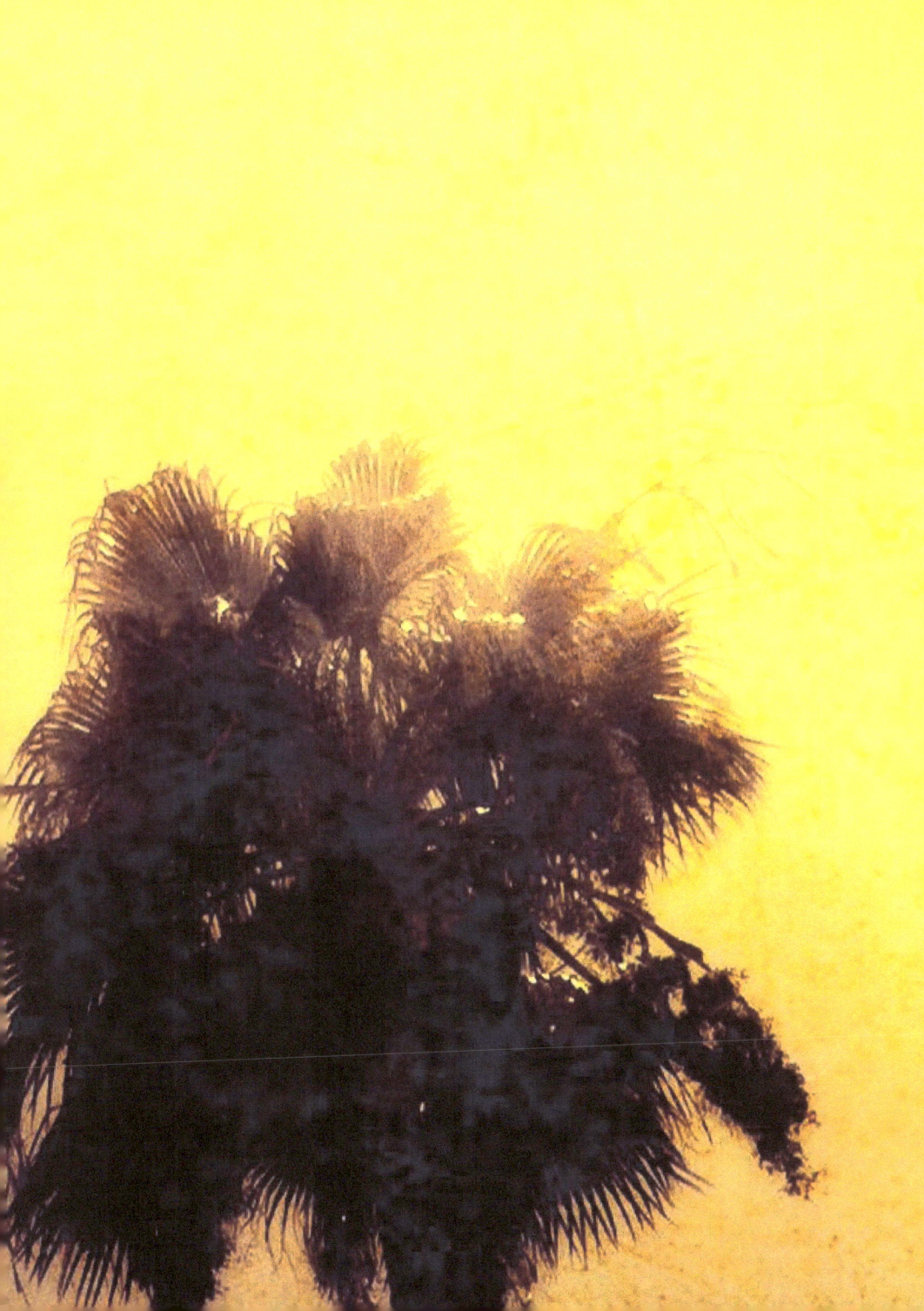

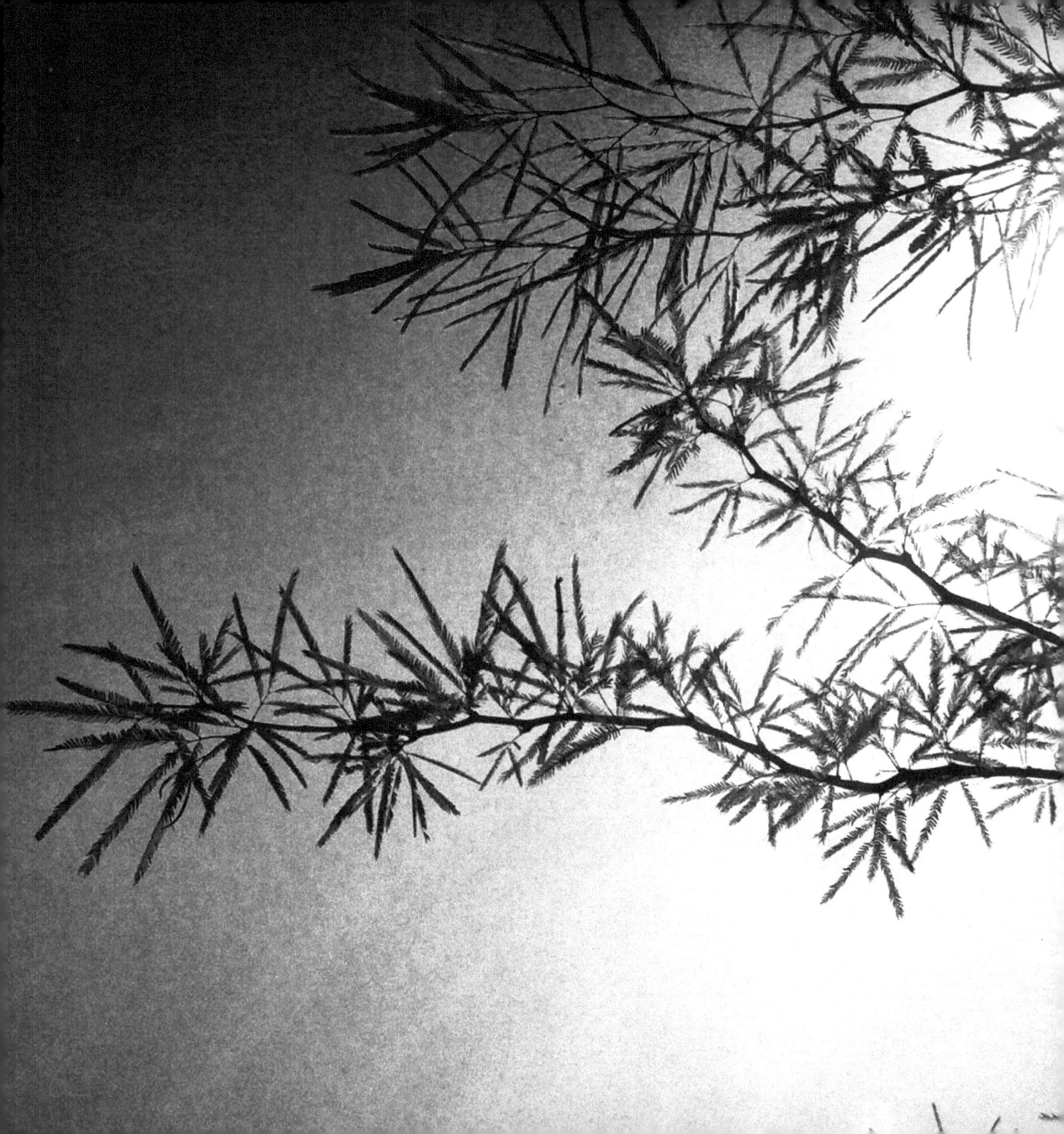

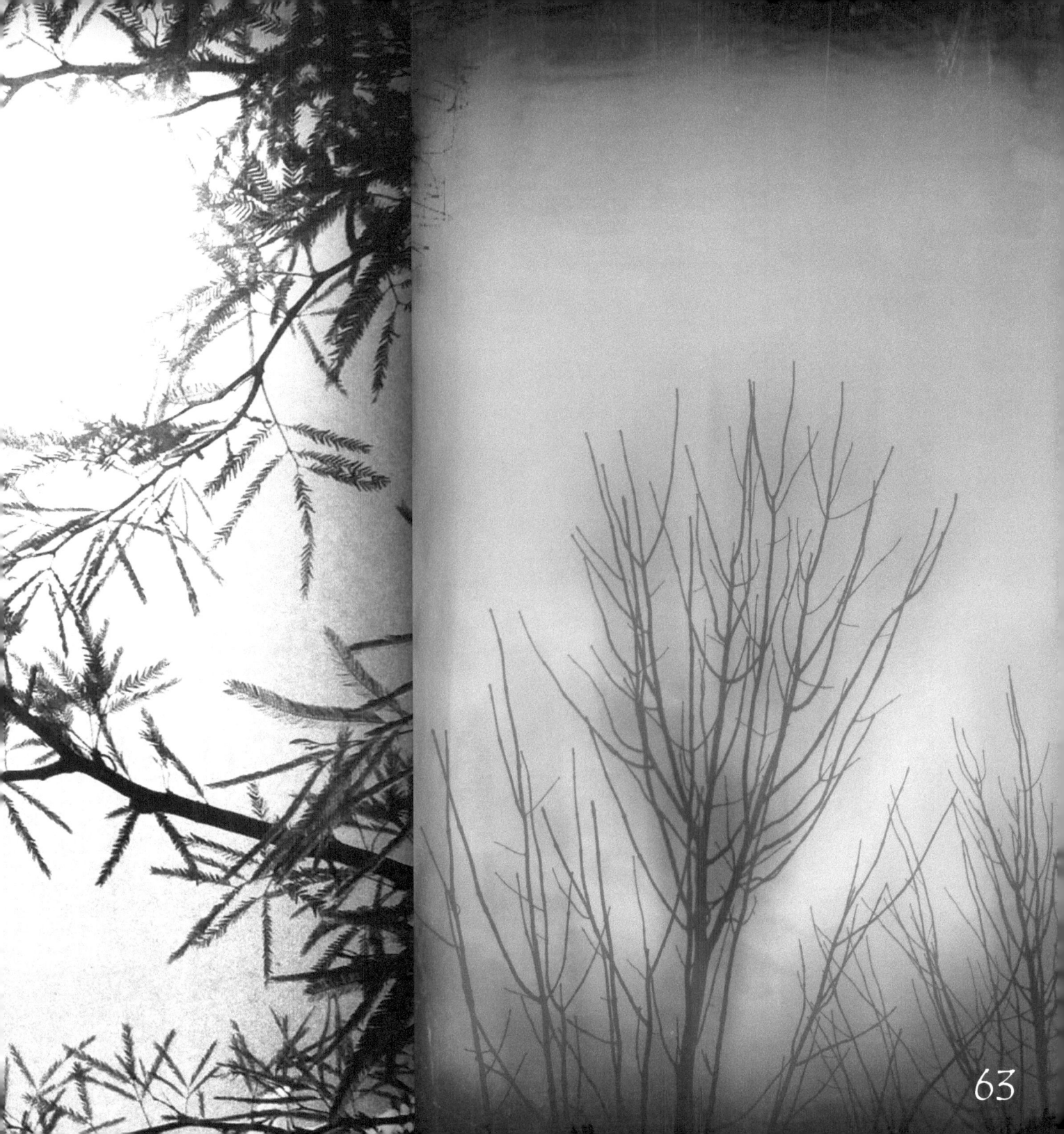

63

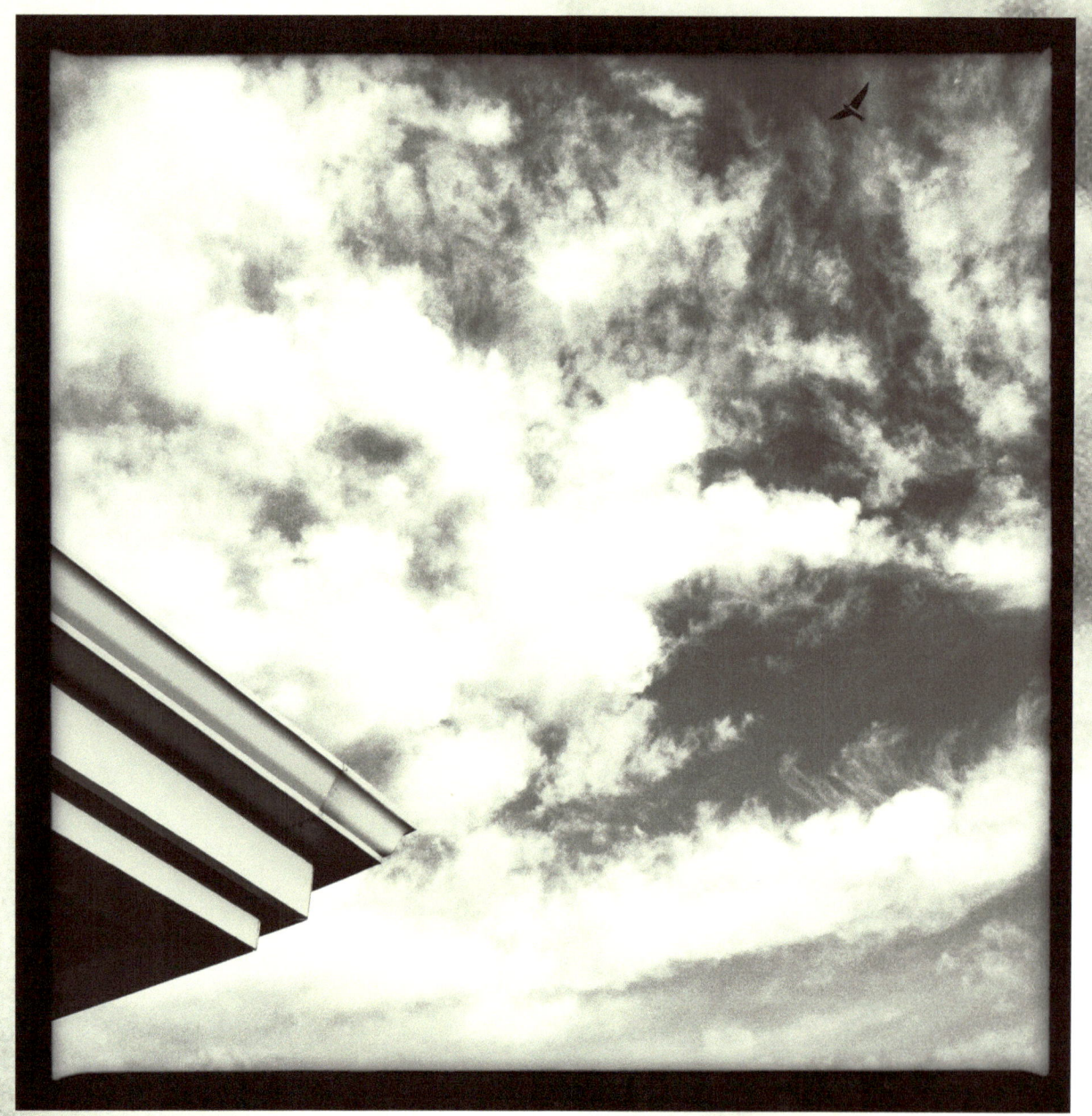

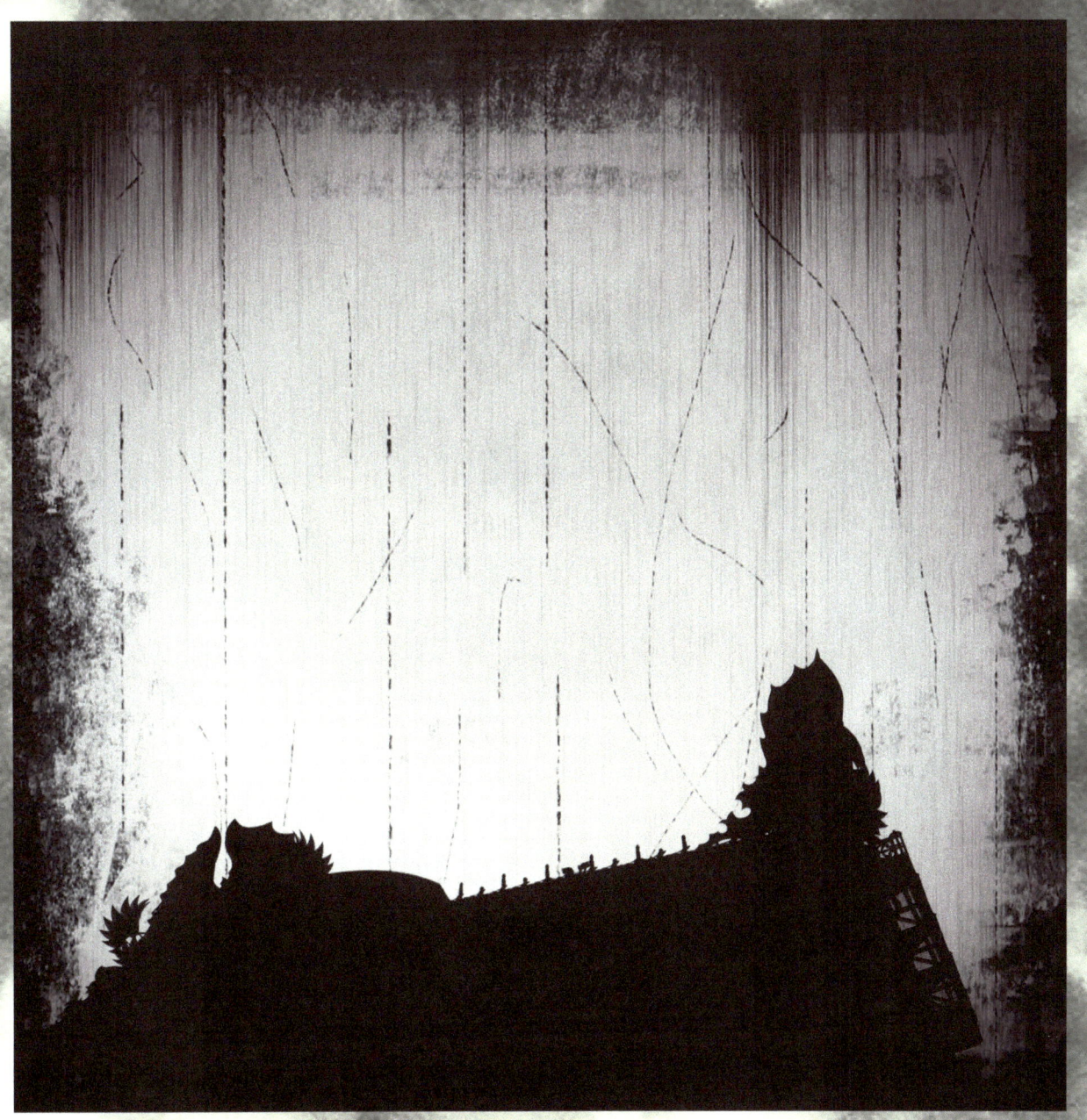

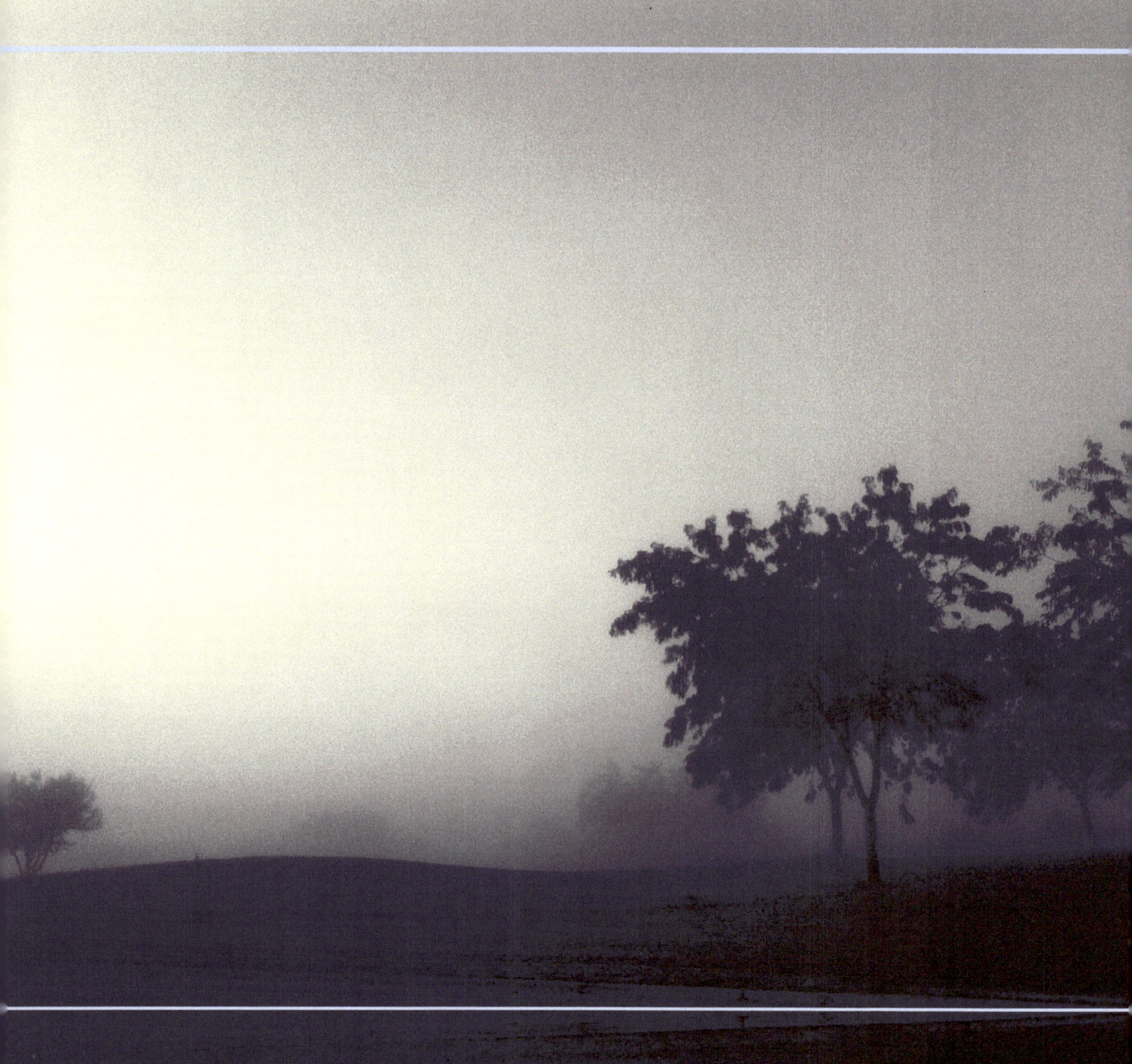

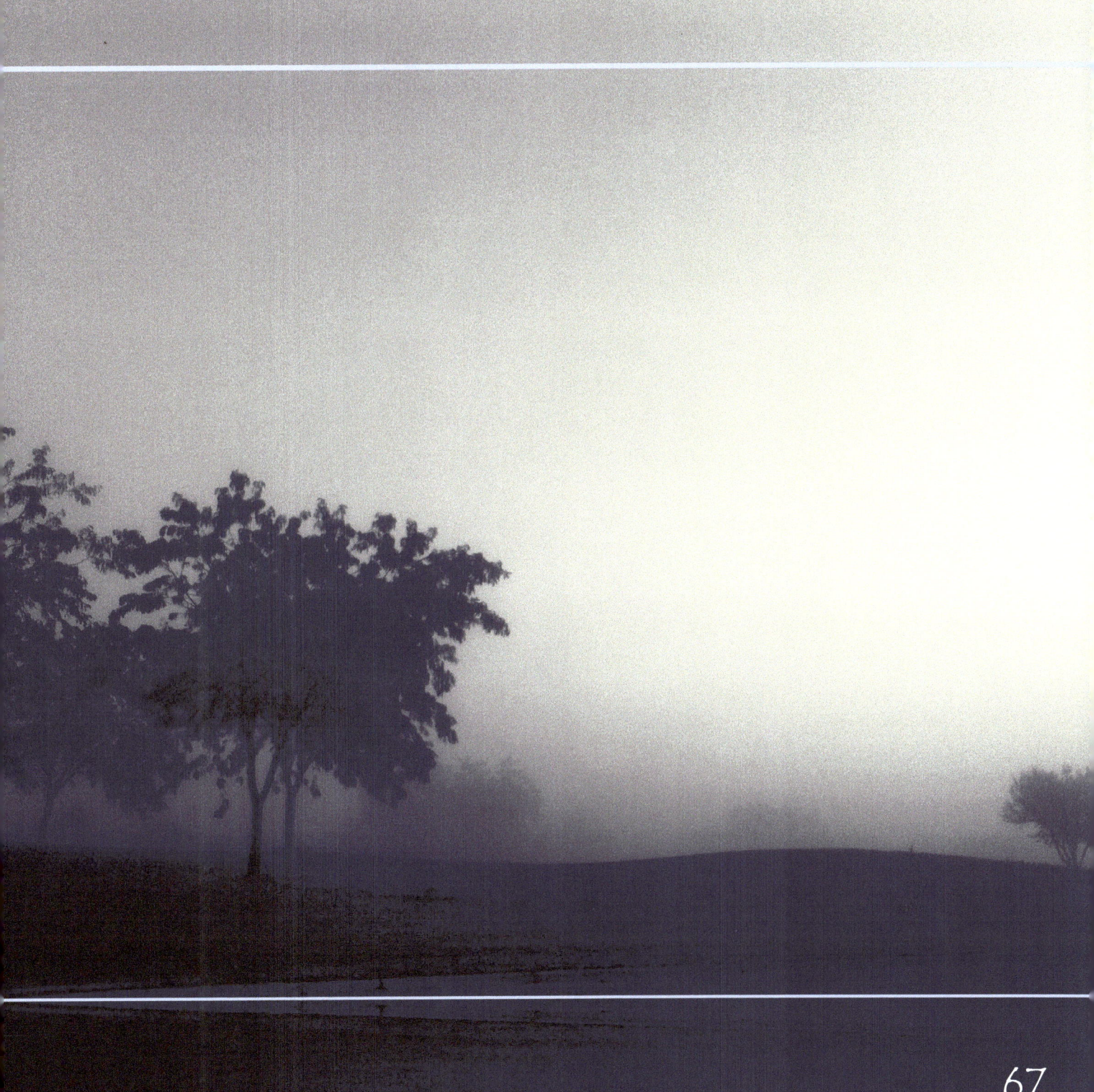

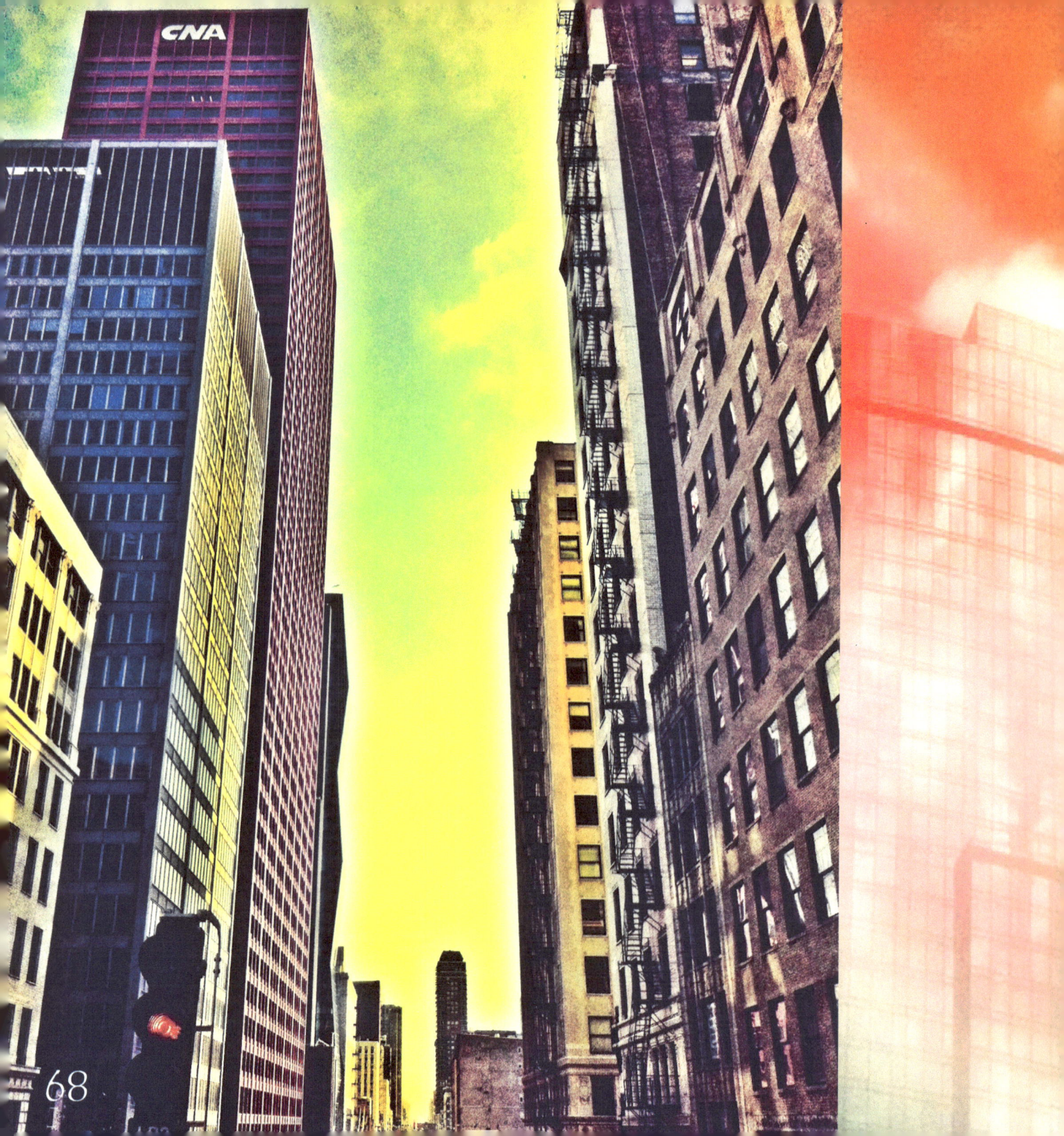

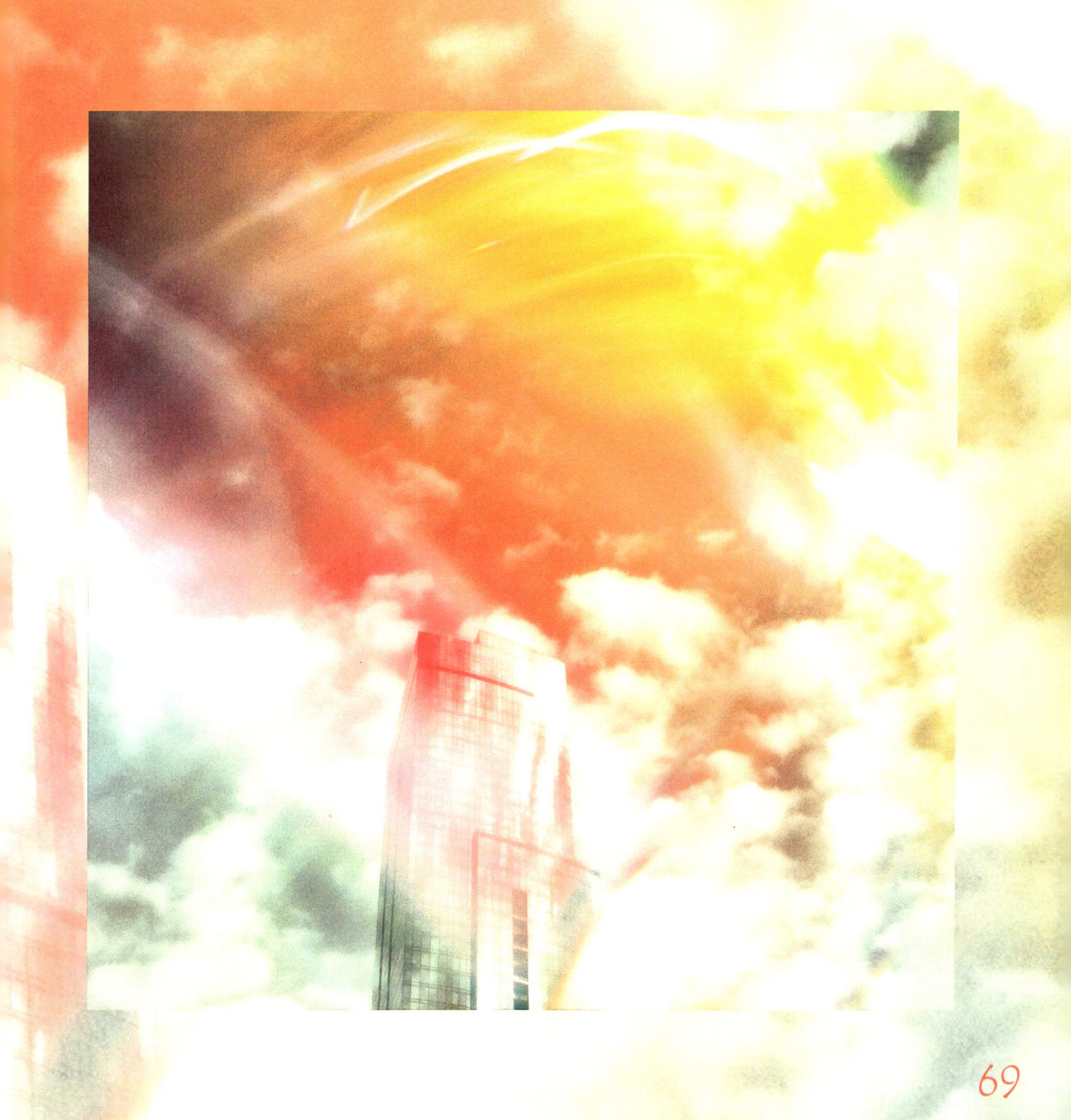

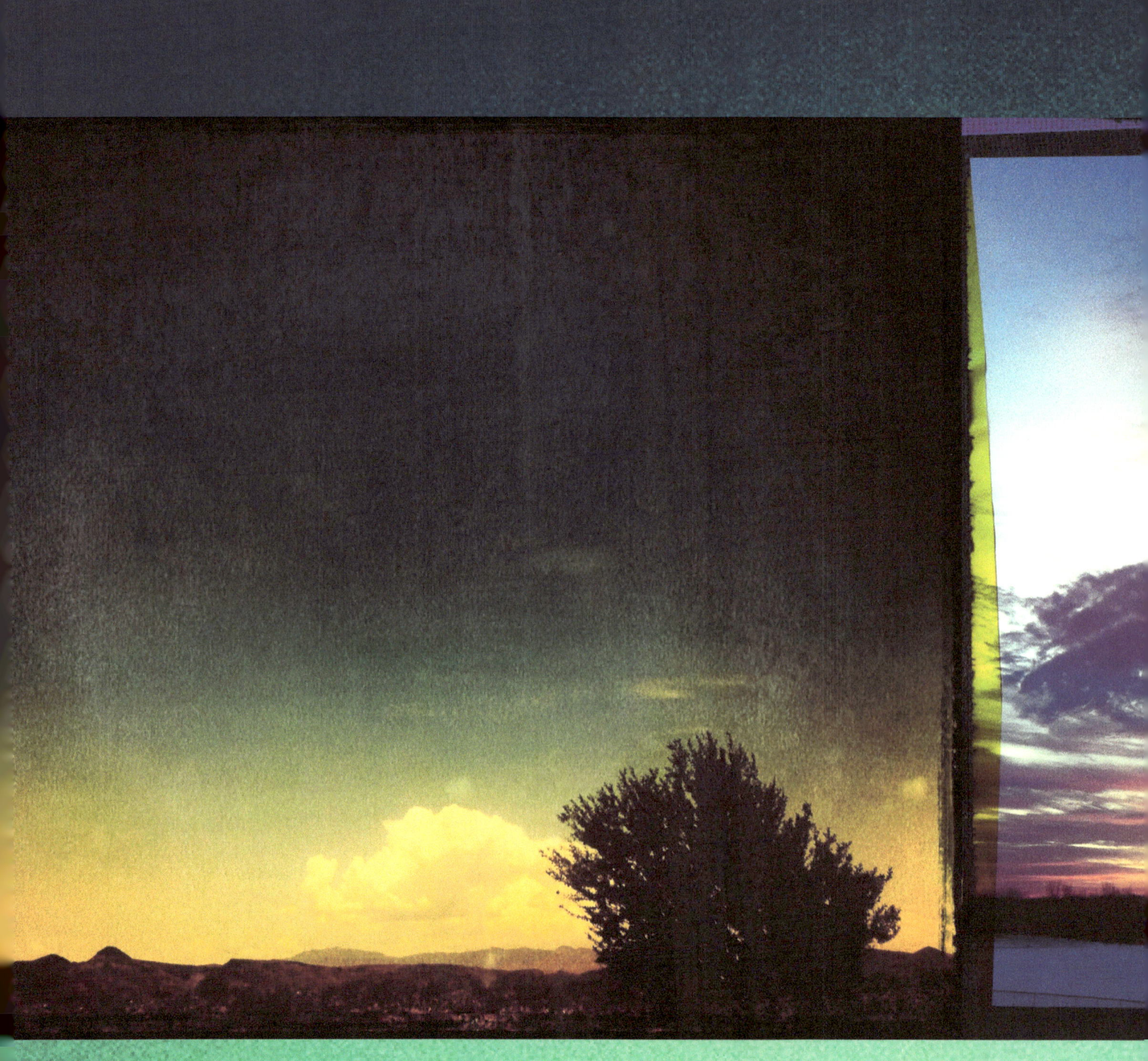

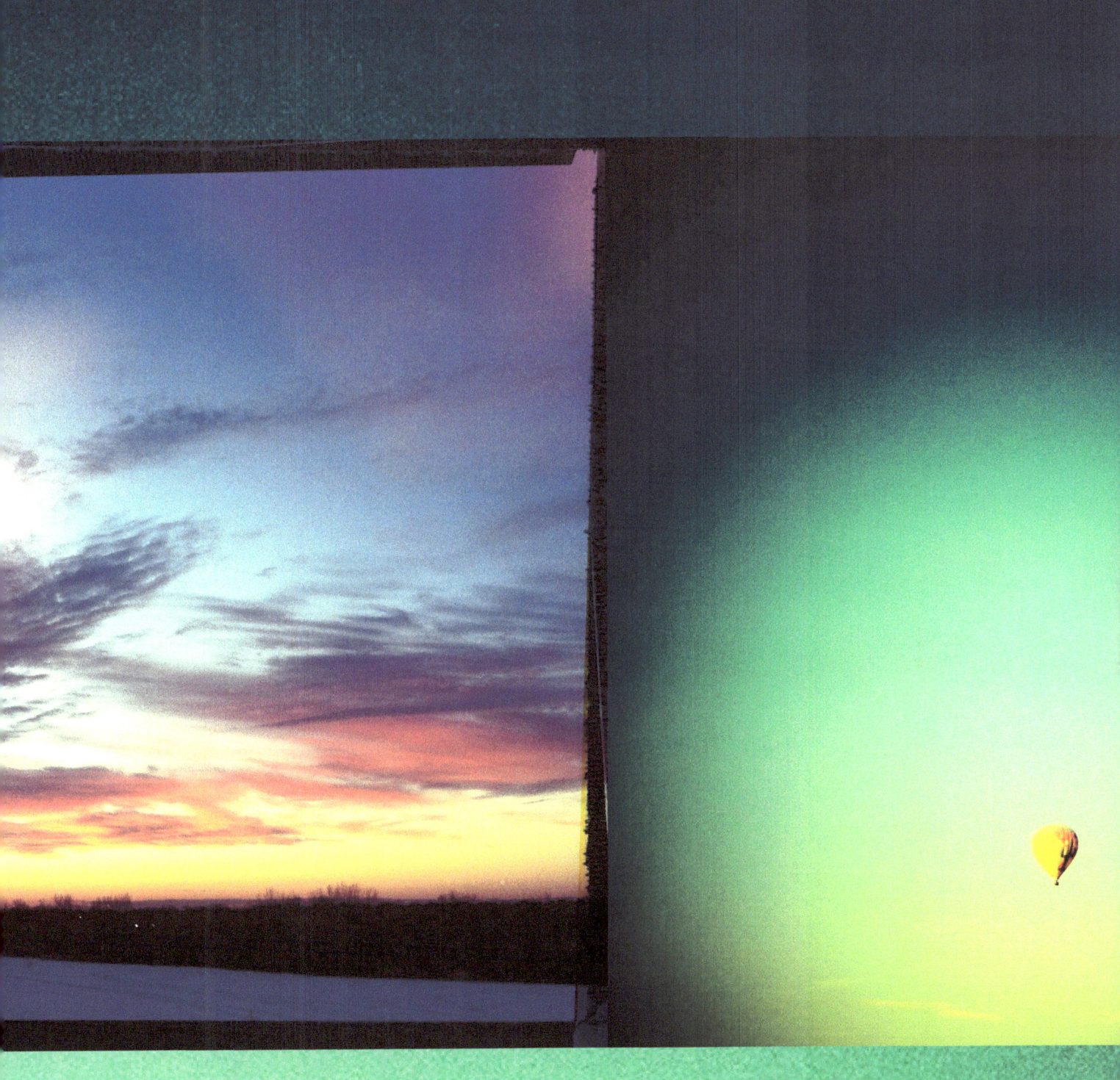

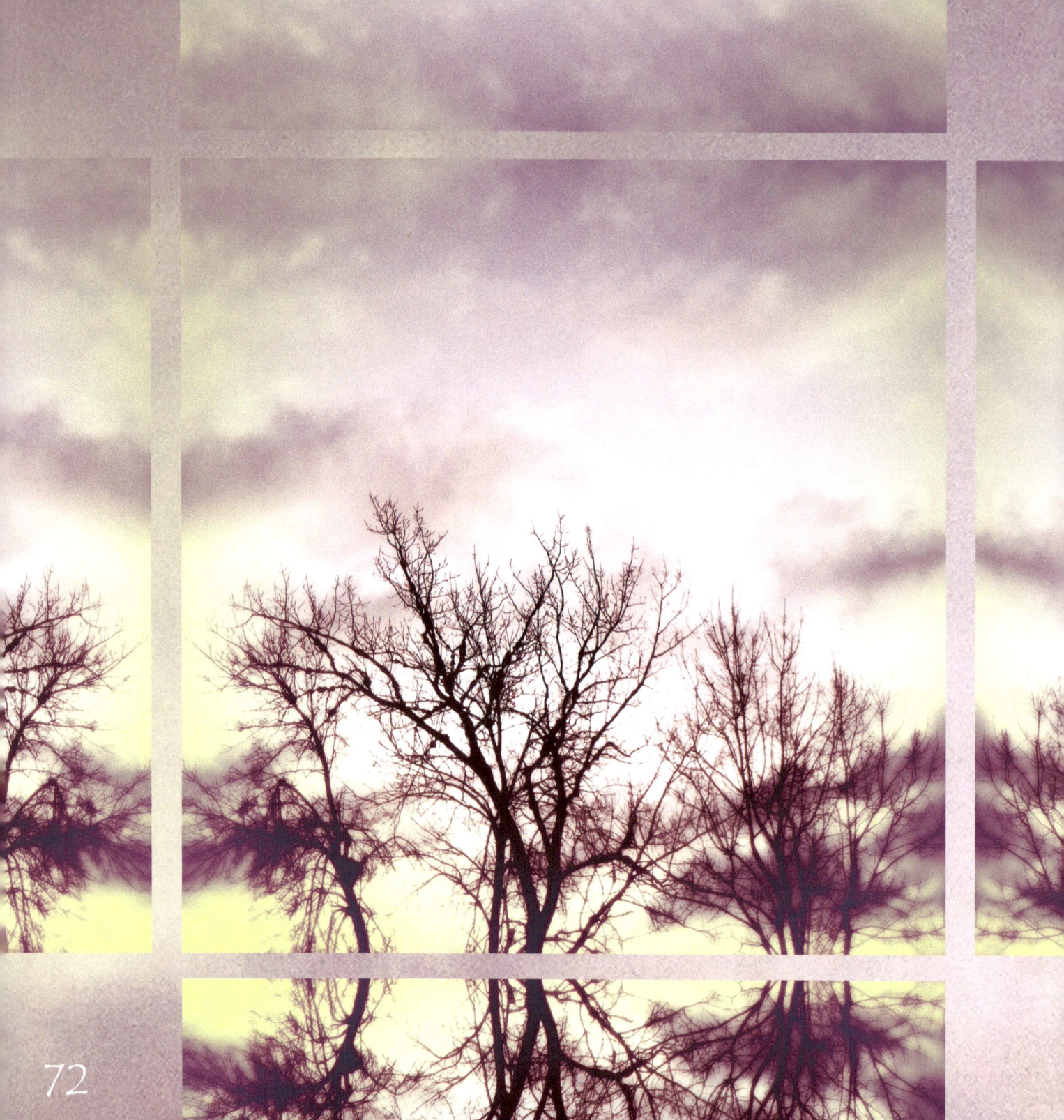

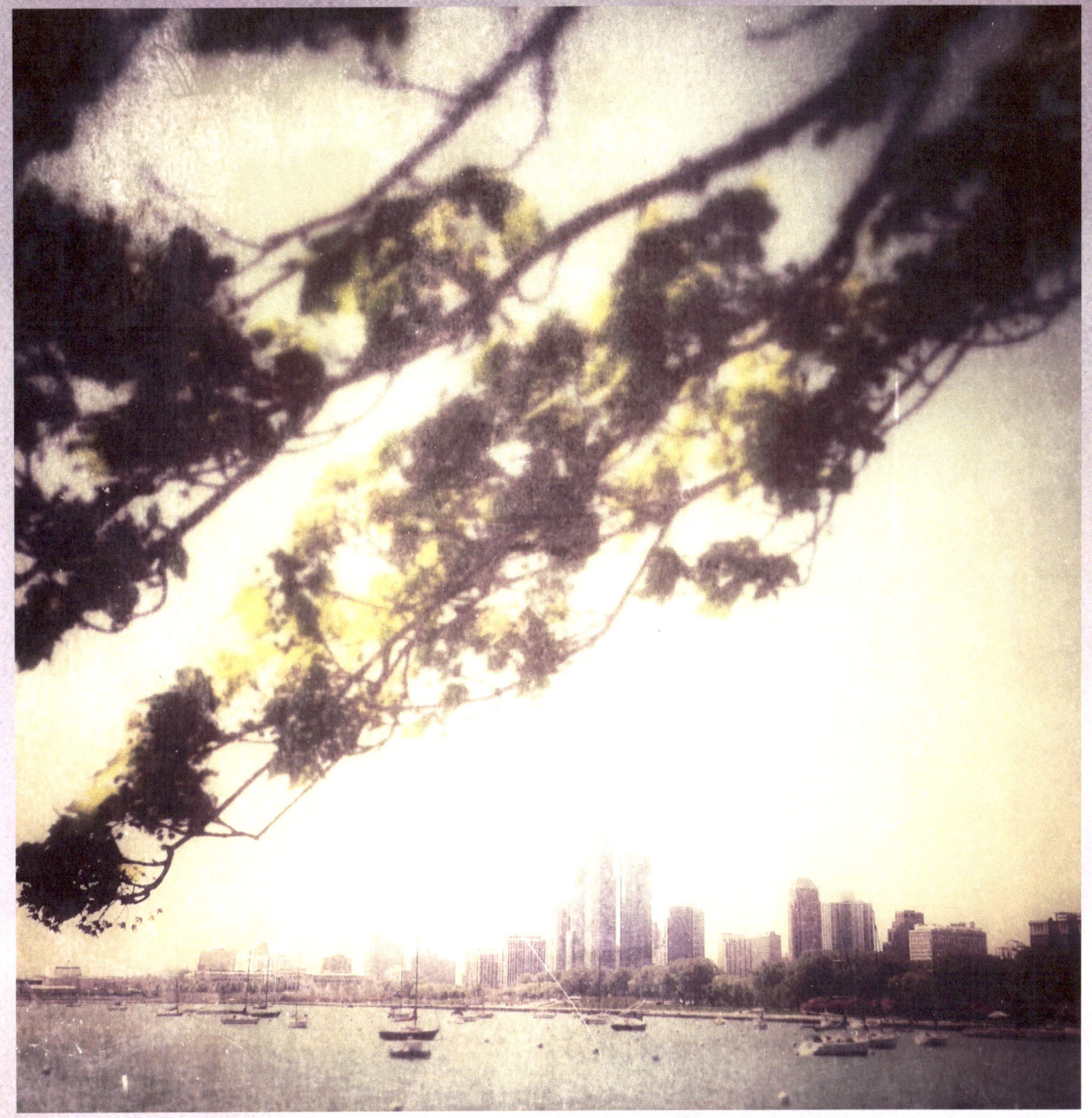

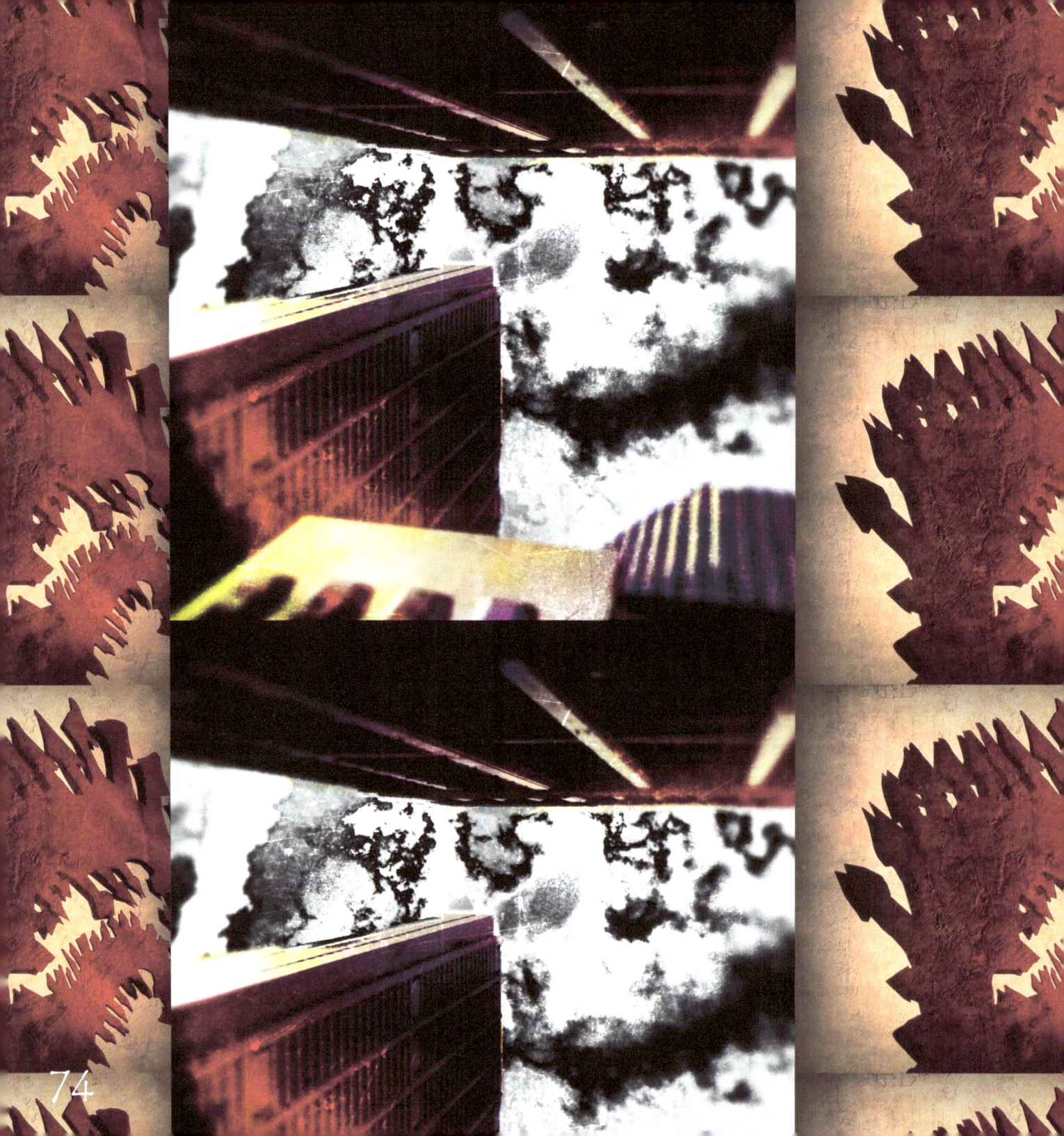

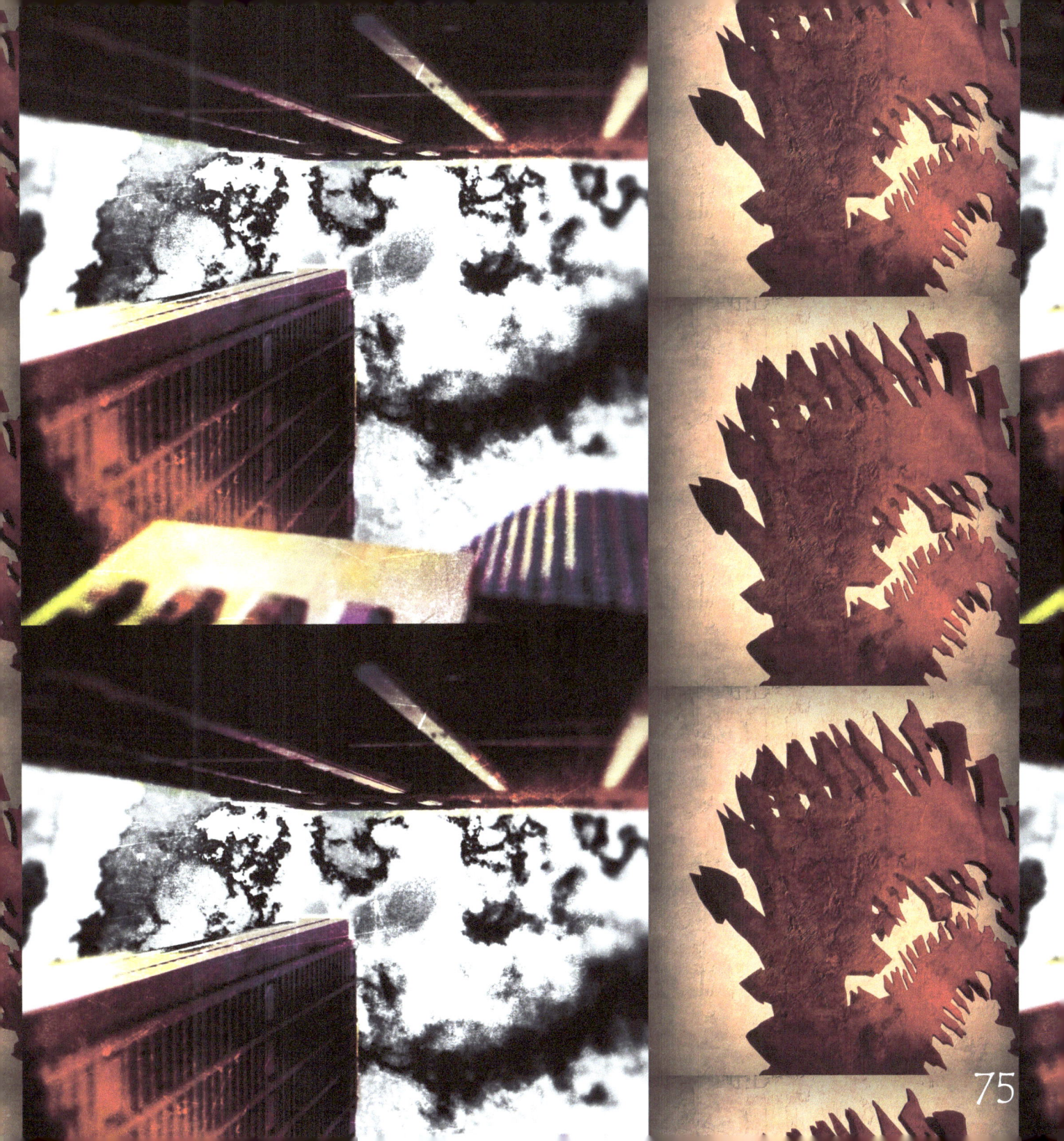

Light Impressions

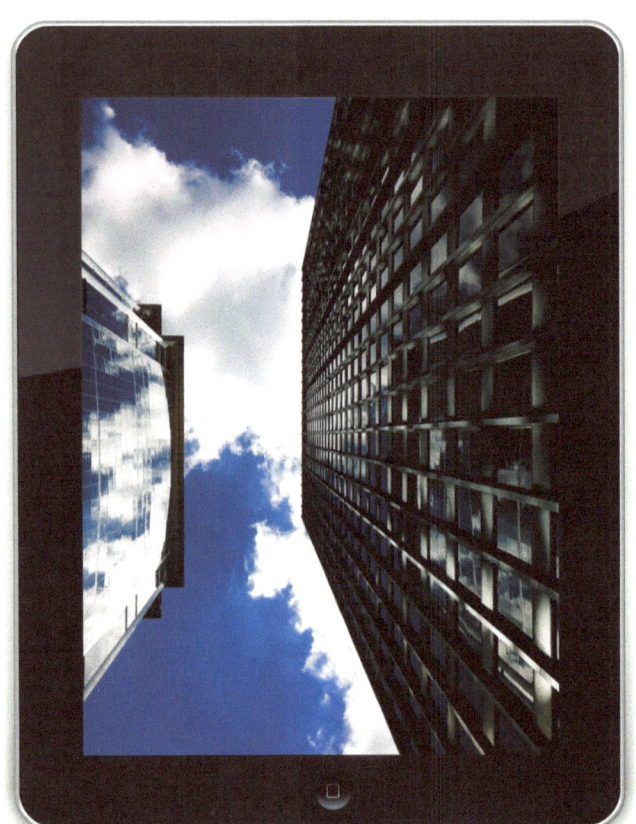

Light Impressions is a Celebration of iPhone photography. It showcases the curated work of 40 iPhoneographers from around the world on 40 iPads. An iPad is assigned to each artist and each unit features 13 images continually looping at different intervals.

The metal structure on which the 40 iPad units are mounted, was made of materials recovered from the wreckage of 1995's Hurricane Opal that had blown off a restaurant.

Since the 2011 grand opening at studio b. in Alys Beach, Florida, gallery owner and curator Colleen Duffley has presented Light Impressions in several venues across the United States. The installation has also traveled to art events in Miami (during the prestigious Art Basel), Austin, TX and Los Angeles for the Mobile Arts Festival.

studiobthebeach.com

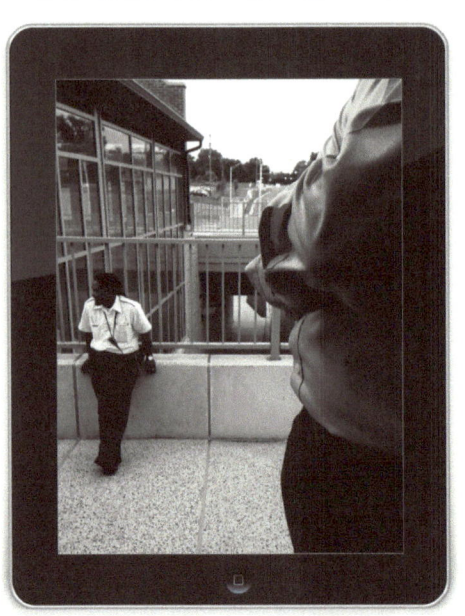
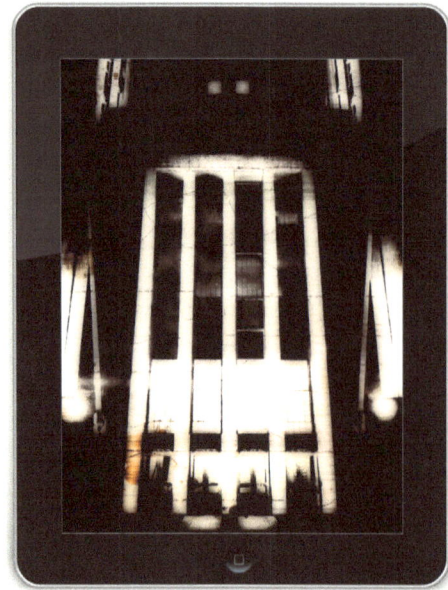
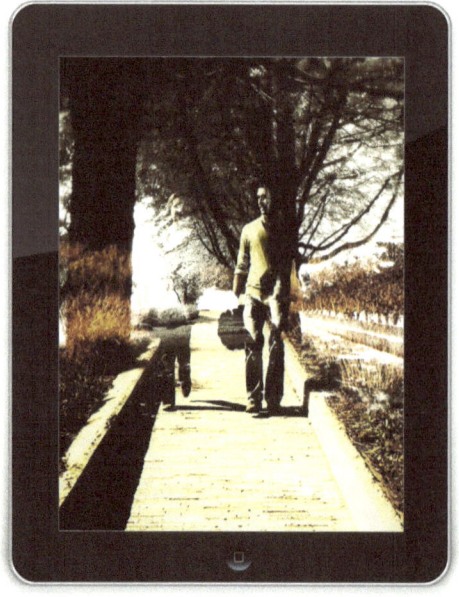

Images displayed were all taken by amaeye and may be updated during the show.

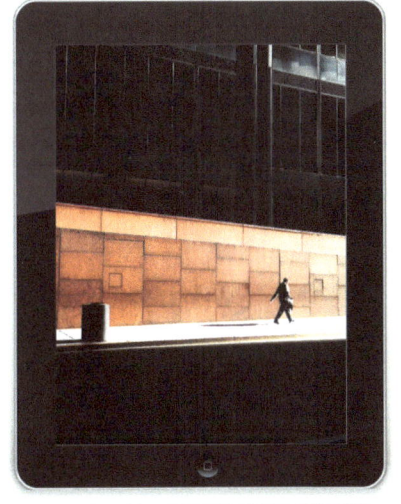
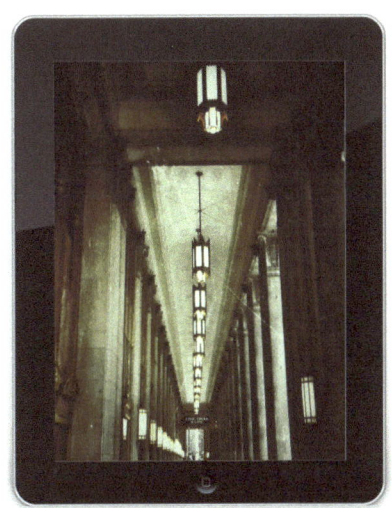
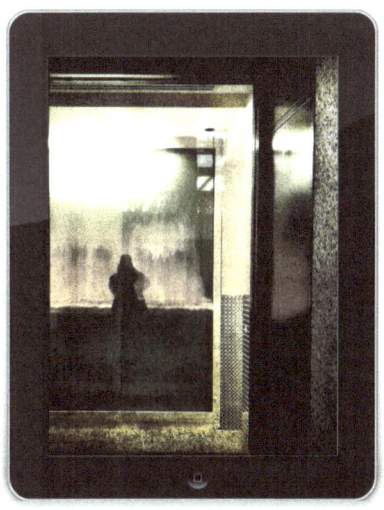
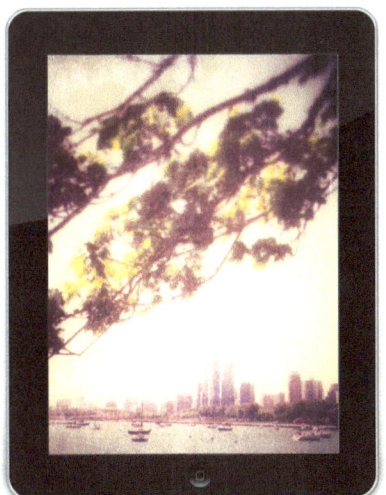
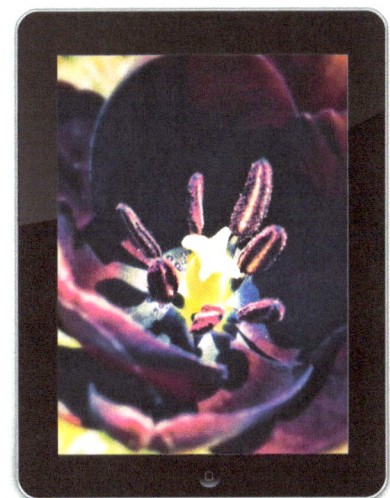
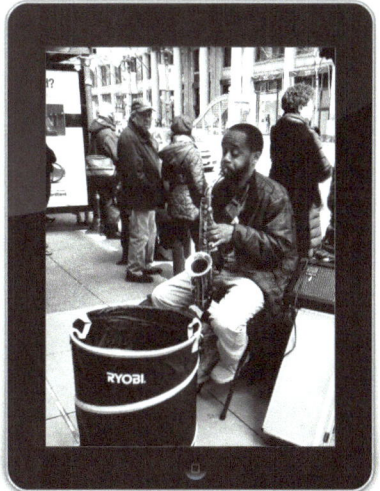
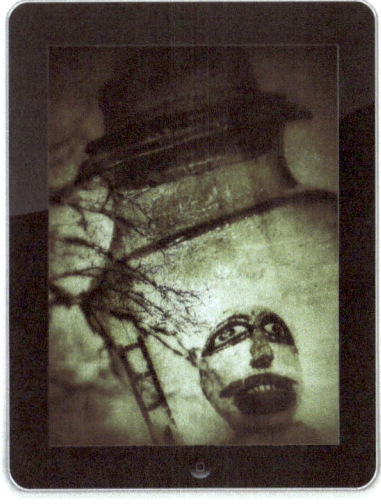
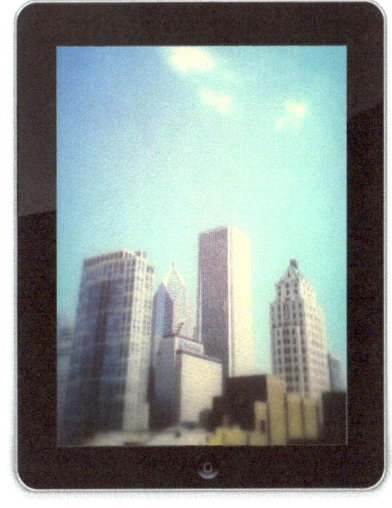
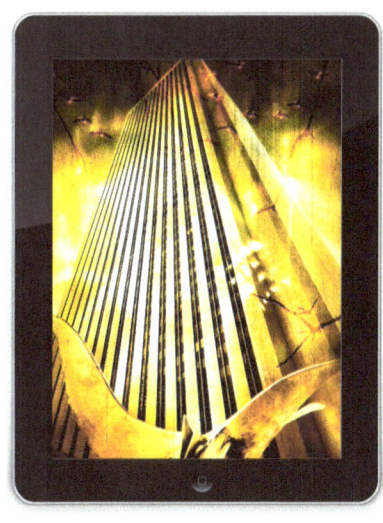

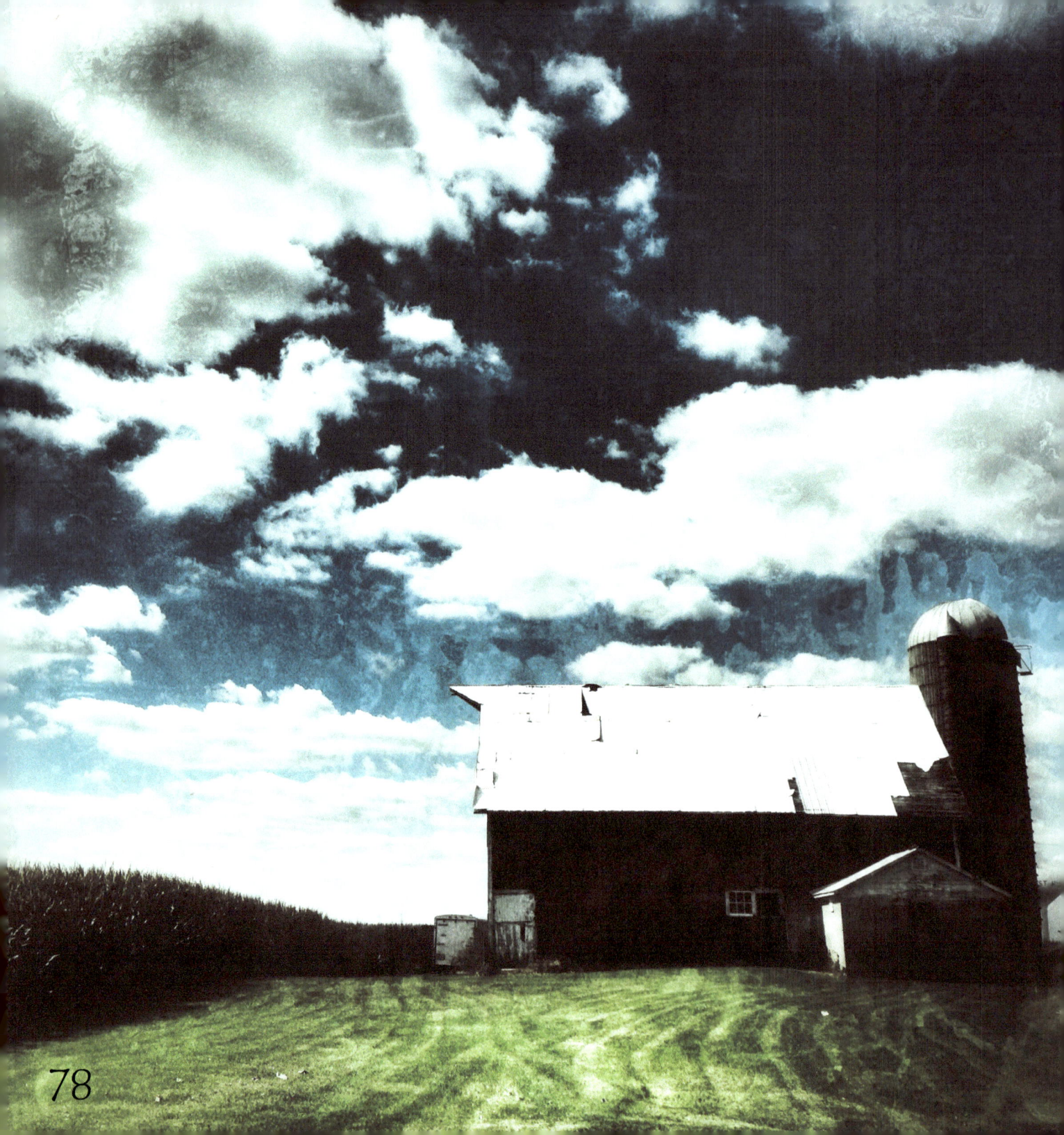

www.ingramcontent.com/pod-product-compliance
Lightning Source LLC
Chambersburg PA
CBHW050739180526
45159CB00003B/1277